BLACK AMERICA SERIES

GREENVILLE COUNTY
SOUTH CAROLINA

BLACK AMERICA SERIES

GREENVILLE COUNTY
SOUTH CAROLINA

Leola Clement Robinson-Simpson

Leola Robinson-Simpson
3/2/07

ARCADIA
PUBLISHING

Published by Arcadia Publishing
Charleston SC, Chicago IL, Portsmouth NH, San Francisco CA

Printed in the United States of America

Library of Congress Catalog Card Number: 2006931259

For all general information contact Arcadia Publishing at:
Telephone 843-853-2070
Fax 843-853-0044
E-mail sales@arcadiapublishing.com
For customer service and orders:
Toll-Free 1-888-313-2665

Visit us on the Internet at www.arcadiapublishing.com

To all the children of the past, present, and future who carry within their indomitable spirit the legacy and heritage of an ageless people; and to all of my precious grandchildren: Rasheera, Taliah, Hakim, Karima, Shakir, Rashiid, Amani, Khaliid, Shaba Omari, Ayana, and Haniyah, as well as Zaylee, Zachary, and Zhryn.

CONTENTS

ACKNOWLEDGMENTS

Writing this book has been an act of faith. As there was no funding assistance, this book depended on the cooperation, patience, and support of many people who contributed to this endeavor. All had a burning desire to be a part of a literary work on the history of Greenville's African American community. Heartfelt appreciation and thanks are extended to the kind and generous contributors who shared archive images or photographs from family collections. Specifically, I would like to express my appreciation to Ruth Ann Butler and the Greenville Cultural Exchange Center; the Greenville County School District; Debbie Spear of the Upcountry History Museum; Sidney Thompson of the Greenville Historical Society; the Schomburg Center for Research in Black Culture of the New York Public Library; Owen Riley of the *Greenville News*; the South Carolina Room of the Greenville County Library; Henrietta Bradford; Ruth Watkins-Smith; John Wesley Jones; Lottie Beal Gibson; Lawrence Acker; Regina Wynder of the City of Greenville Community Development Department; Eric Carpenter of the Phillis Wheatley Association; Joe Jordon; Dr. Ann Pinson; Marie Peterson; WJMZ 107.3 JAMZ Radio; and the many "way makers" who shared their personal photographs.

A very special appreciation is extended to David Ezell Henry Jr. for his incredibly realistic sketches. I would also like to express my appreciation to Adam Ferrell, former editor, and Lauren Bobier, Arcadia's southern publisher, who provided ongoing direction and assistance in moving this book from concept to publication.

I am profoundly grateful to Peggy Baxter, Jo Ann Long, Gloria Isles, and my daughter Dr. Aminah Richburg for sharing their expertise.

My entire family has kept me going. My wonderful husband, Albert Simpson Jr., has been my anchor. My sons, Basheer, Hassan, Shakir, and William Talib; my mother, Rosa Lee Clement; sisters Geneva McCoy, Mildred Harris, Rose Mary Clement, and Marilyn Clement; brother-in-law Rev. Andrew McCoy; and nieces, nephews, and cousins have all prodded me gently along.

AUTHOR'S PREFACE

In 1986, author Leola Clement Robinson-Simpson was a member of the Greenville County Bicentennial Committee. This committee was formed under the auspices of the Greenville Urban League and charged with compiling African American contributions in Greenville from 1786 to 1986. The bicentennial committee was cochaired by Alberta T. Grimes, Rev. Joseph D. Mathis, and Sam Zimmerman Sr. The coordinator was Sylvia Wood-Fowler. Other committee members included Myron Robinson, executive director of the Greenville Urban League; Julia Adams; Ralph Anderson; Judith Gatlin Bainbridge; Douglas Brister; Ruth Ann Butler; Rev. S. C. Cureton; Ennis Fant; Fred Garrett; Lottie Gibson; Morris Hall; Thomas Hooper; Mattye Jones; Thomas Kerns; Jeanne Lenhardt; Carol Martin; Dorothy Mims; Xanthene Norris; Bobby Settles; Lenny Springs; Doug Smith; Joseph A. Vaughn; Rev. Q. H. Whitlock; and Rev. Willie Wilson. This committee conducted research, collected images, and produced the booklet *We Are a Part of the Bicentennial Celebration of Greenville County: 1786–1986*. Unfortunately, none of the photographs or images collected in 1986 was included in the bicentennial-committee booklet.

Thirty years later, the author, a longtime civil rights activist, educator, school board member, and founder of the Center for Educational Equity (CEE) Saturday Success School, was moved to write Black America: *Greenville* because of students who wanted to know more about the early history of African Americans in Greenville. This daunting task involved collecting images from the past and resurrecting some of the findings of the bicentennial committee and the research of Joseph D. Mathis. Some of the images collected could not be reproduced due to poor photographic quality. The references to the terms "African American" and "black" in this book are reflective of the generational metamorphosis of a people who stretched the limits from survival to unheralded accomplishments from the 1700s to the present.

Young people today have many opportunities for a brighter future because of our past. The resilience of African Americans in Greenville and their stellar achievements in spite of adversities must be recognized as more than a footnote in local history. Enveloped in this recognition is the challenge to African American youth, in particular, to continue the proud legacy of achievement in the future.

INTRODUCTION

The roots of African Americans in Greenville run deep into the red soil of the Upstate and can be traced back to before the Revolutionary War, when Greenville was a wilderness. The story was told by Lydia Dishman that Virginia trader Richard Pearis brought 12 enslaved Africans with his wife and three children when he cleared about 100 acres around Reedy River Falls on land acquired from the indigenous inhabitants, the Cherokee Indians, in 1770. By the mid-1800s, Greenville was thriving. The *We Are a Part . . .* booklet states, "this upcountry town was primarily a summer resort for rich white folks from Charleston and the Low Country." The white settlers did not come alone. Their enslaved servants traveled with them and laid the foundation for Greenville. The unwavering belief that the servants would one day be free cemented the docile and compliant relationship with their captors and fueled incredible African American achievements against the odds.

Though Greenville was a traditional mill town, employment in manufacturing tended to be restricted to the white populace. However, in the 1870s, there were 70 African American businesses on Main Street in Greenville, including six barbershops, three retail stores, one meat market, and three restaurants, and the only brick manufacturing company in town was owned by an African American businessman. African American businesses flourished and spread to adjacent downtown streets. Thrifty and business-savvy African Americans accumulated sizable amounts of property and wealth though recently freed from bondage.

Unfortunately, with the rise of Jim Crow and the Klan in the 1900s, African Americans lost control over the traditional barbering, hacking, and drayage industries, as well as over the downtown stores in Greenville. As the older established African Americans passed away from the scene, they were systematically replaced by whites. It was during this sad era in Greenville's history that whites began the process of wrestling from the hands of African Americans the prized businesses and property that had been owned by African American families since the early 1800s. For instance, Joseph D. Mathis found that the Mansion House Barber Shop in Greenville had, from its founding, been operated by African Americans. However, in 1898, it began advertising that its barbers were "all-white tonsorial artists, none but the first class employed."

After the Civil War, African Americans had a burning desire to be educated. According to *We Are a Part . . .* , an early African American school was located in a log cabin at Jubilee Baptist Church. Many of the trailblazers in education have long been forgotten. In 1866, Charles T. Hopkins, a freedman, with the help of Lewis Rivers and Cecil Coleman, began

teaching African American children in a room of a deserted hotel using his personal resources. Massalina V. Lawrence Bowens taught for 50 years at the Allen School starting in 1909. Her motto was, "I am not so much a teacher as I am a reacher. I strive to reach the hearts and minds of each child with whom I come into contact." Prof. John Henry Chapman founded the Chapman Grove School under trying circumstances in the 1920s.

Ten years after the 1954 Supreme Court decision in *Brown v. Board of Education*, the federal courts finally intervened to address "separate but equal" public education. The courts issued an order for "freedom of choice," allowing Elaine Whittenburg, L. R. Byrd, Donald Sampson Jr., and two other students to enter formerly all-white junior and senior high schools in Greenville amid much racial tension and protests. District-wide desegregation was mandated on February 17, 1970, with African American students bearing the brunt of the burden. All–African American schools that had been a bootstrap for academic excellence, leadership, character building, and service for more than five generations of African Americans in Greenville were no more. Sterling High School burned; Lincoln High School became a career center; Bryson High School was downgraded; Washington High School became a center for special needs; Beck High School was downgraded to a middle school; Allen School and Oscar Street School were closed; Gower Street School became an early childhood center; and Sullivan Street School became a book center and a center for alternative programs. African American teachers and students were split up and reassigned to formerly all-white schools scattered district-wide. More than 30 years later, a shameful gap in achievement among students and a disturbing decline in the numbers of African American educators as role models were revealed.

African Americans were soon invited into the basements and galleries of white churches so that they could follow Christianity; the religious practices of Africa were prohibited. During Reconstruction, many former slaves left the balconies and basements of white churches to form their own churches. The African American church quickly became the bedrock of the community. In the such churches, African Americans could lead and not simply follow.

Housing patterns for African Americans in Greenville are an outgrowth of the early relationship between whites and their African American servants. In Greenville, African Americans lived on or near every street and section of town. It has been said that whites desired to keep their enslaved workers divided and close to them. Segregation in housing and the cost of rents limited the choices many blacks had for affordable housing. Therefore, black neighborhoods in every section of town boasted a mixture of incomes, education levels, and occupations among residents. This situation produced role models in the community for the young and fostered a sense of community and pride, while subliminally perpetuating the Willie Lynch slave mentality.

Social life was the tie that bound the African American community together. Social events were for the purpose of friendship, fellowship, and fund-raising for worthwhile causes. It was during the late 1800s and early 1900s that African American people in Greenville began to organize African American improvement societies and benevolent lodges to give aid to the sick and needy and to bury the dead. Later federated clubs, various social clubs, sororities, fraternities, and Masonic orders were founded with lofty goals in mind. Funds for worthy community causes were generated by sponsoring dinners, dances, parties, and sporting events. The revenues from these events were used to uplift the community.

Way makers are individuals who paved the way for others to follow. According to *We Are a Part . . .* , during Reconstruction, W. B. Thompson, Wilson Cooke, Charles T. Hopkins, and Thomas Grier served in public offices. Rev. W. B. Thompson and Wilson Cooke were elected to the state legislature in 1868. Wilson Cook and a W. H. Bishop were later elected to the state general assembly, though both served only one term. Charles T. Hopkins and

Thomas Grier were appointed in 1877 to serve as judges. According to *We Are a Part . . . ,* the token African American role in Greenville can also be seen in the appointment of Thomas Lewis to the position of second assistant to the chief of the fire department by the Greenville City Council. In 1886, S. S. Thompson was appointed to the school board in Greenville, reportedly by a Democratic party majority, to "dispel the notion that only the Republican Party provided opportunities for African American involvement."

In 1948, African Americans were allowed to register and vote in Greenville. Blacks who ran for office in the late 1960s and early 1970s included attorney Donald James Sampson, Harrison Reardon, and businessman L. R. Byrd. Bishop Johnny Smith ran for a place in the House of Representatives. Rev. D. C. Francis and businessman Melvin Davis ran for county council; Harry Bowens ran for mayor; Rev. W. R. Martin, Rev. C. Mackey Daniels, businessman Robert Settles, attorney Alex Kinlaw, and Rev. Johnny Flemming ran for the school board. During the late 1970s and early 1980s, Rev. J. W. Henderson, civil rights leader A. J. Whittenberg, and educator Joseph Vaughn ran for the city council; attorney Dorothy Manigault ran for the senate; and Rev. S.C. Cureton ran for the House of Representatives. During the 1970s, state reapportionment created single-member districts, which included two majority African American districts in Greenville.

Elections and appointments followed. In 1973, Dr. E. L. McPherson was appointed to the city council. Starting in 1977, elections to office included Rev. Rayfield Metcalf to city council, followed by Rev. Joseph D. Mathis, educator Lillian Brock Flemming, postmaster Ralph Anderson, businessman Raymond Martin, and Chandra Dillard. In 1974, Bishop Johnny Smith was elected to the county council. He was followed by Rev. E. D. Dixon, Rev. Ennis Fant, attorney Fletcher Smith, civil rights veteran Lottie Gibson, and educator Xanthene Norris. Attorney Theo Mitchell was elected to the house of representatives in 1974 and served until he won the senate race in 1984. He was followed in the house of representatives by educator Sara Shelton, Rev. Ennis Fant, councilman Ralph Anderson, and attorneys Fletcher Smith and Karl Allen. House member Ralph Anderson followed attorney Theo Mitchell in the senate. In 1972, Dr. Alex Chambers was elected to the school board. Attorney Willie T. Smith filled Chambers's unexpired term in 1973. Others elected to the school board were Rodney Acker, Blanche McIver, Vivian Richardson, Dr. Grady Butler, attorney Andrew M. Jones, and educator Leola Clement Robinson-Simpson. However, black officials are often out-voted on certain issues. A notable way maker in business was Dr. William Sloan Gandy, a gifted physician who built the upscale Gandy Plaza (an African American shopping center on East Broad Street) and the Ghana Motel and Restaurant on I-85 during the 1950s.

Civil rights became a clarion call when Jim Crow reared its ugly head in the early 1900s. Jim Crow laws were strictly enforced. The Ku Klux Klan rained terror on African American folks in Greenville. A few brave African Americans organized the Greenville NAACP on September 12, 1938, in response to the Night Riders, cross burnings, and several lynchings. The 1947 lynching of Willie Earle, a young African American man, by a group of white cab drivers focused the attention of the world on Greenville. In 1959, the student protest movement, with "sit-ins," was ignited in Greenville.

On May 17, 2003, Greenville native Rev. Jesse Jackson led a march for justice. More than 30,000 people marched across the Church Street Bridge in Greenville to the offices of the Greenville County Council to protest the council's refusal to declare the birthday of Dr. Martin Luther King Jr. a paid county holiday. The struggle continues to close the gaps between students. The rusty chains of enslavement and free labor in the past cannot become the chains of incarceration and free labor in the prison industry today.

One

SLAVERY AND RECONSTRUCTION

Slavery has been described as that "peculiar institution" that allowed man's inhumanity to man for more than 400 shameful years in American history. Slave traders justified the sale of human beings as cargo by calling them "savages" rescued from the "dark" continent. William Loren Katz found that the real Africa in the 15th century was quite different from the Africa described by slave traders. Katz stated that the kingdom of Songhay in West Africa had developed a banking system, a system of free education, and a code of laws by the 15th century. More than 500 years before the birth of Christ, Africans were building great cities, tilling the soil, smelting iron ore, and fashioning leather, wood, glass, gold, ivory, copper, tin, silver, and bronze. Africans carried works in weaving, winemaking, pottery, and smithery in huge caravans that displayed their riches. Katz wrote that the University of Sankore at Timbuktu offered courses in surgery, law, and literature. Manuscripts from the libraries were sold for more money than any other merchandise. It was in this environment of African prosperity and greed that the slave trade began and a labor force of free and often highly skilled labor was extricated from the African continent and brought to ports in the South and made into slaves, as described in *The Making of a Slave*. It has been said that only the most docile, skilled, loyal, and faithful enslaved were brought to Greenville. With compliance came rewards. With rebellion came harsh punishments. The slave trade followed the dollars to Greenville. As the Upstate grew, according to images in the Baley Collection, human beings of a darker hue were sold from the balcony of the Old Slave Mart, also called the Record Building, to the highest bidder.

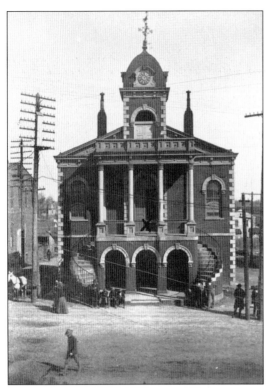

The photographer C. L. Baley inscribed an X on the second floor balcony and wrote, "Old Slave Mart in Greenville S.C.—Slaves were sold from the porch." (Courtesy of the C. L. Baley Collection, Schomburg Center, New York Public Library.)

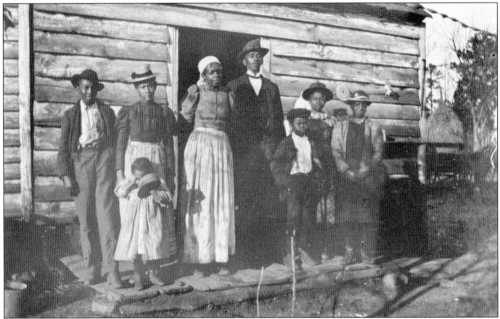

This is a vintage photograph of a black family posing outside their cabin. This photograph was taken near Camp Weatherill, near present-day Earle Street. Camp Weatherill was an army camp in Greenville, South Carolina, in the years 1898–1899. This image reflects the pride and dignity of black families in the late 1800s. (Courtesy of the C. L. Baley Collection, Schomburg Center, New York Public Library.)

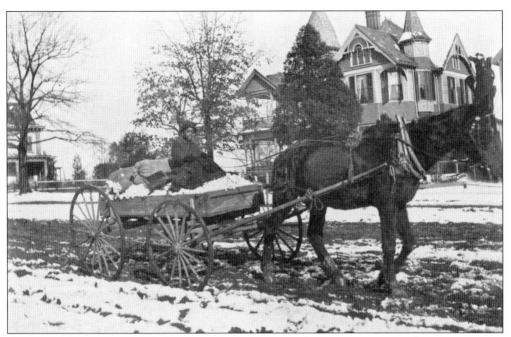

This image was taken on a Greenville Street in February 1899. An African American youth is driving a horse-drawn wagon with a load of raw cotton in the snow in what photographer C. L. Baley described as the "Sunny South." (Courtesy of the C. L. Baley Collection, Schomburg Center, New York Public Library.)

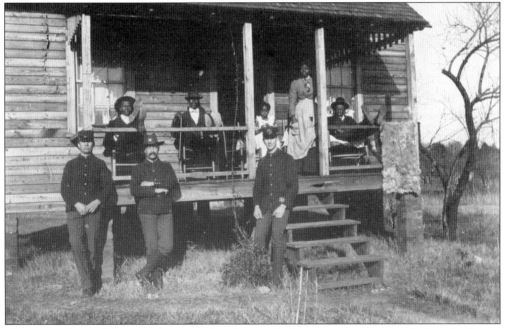

Three members of the 203rd New York Volunteer Infantry are seen posing before the home of an African American family with family members seated on the porch in Greenville, 1898–1899. Photographer C. L. Baley named this image "Jolly, Conklin, and Dangesman." (Courtesy of the C. L. Baley Collection, Schomburg Center, New York Public Library.)

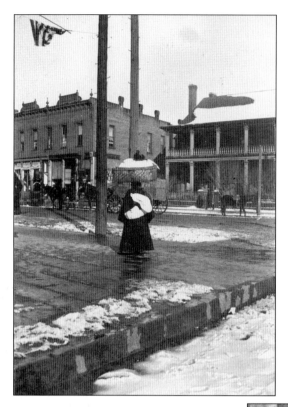

Photographer C. L. Baley took this image of a "Negro Laundry Auntie" on Main Street. A woman carries bundles of laundry in a basket on her head, with a hat on top of the basket. This image gives a clear view of buildings on Main Street and the presence of African Americans during this period. (Courtesy of the C. L. Baley Collection, Schomburg Center, New York Public Library.)

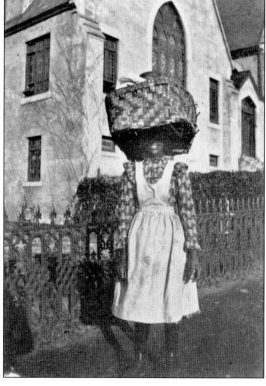

This is an image of, as Baley noted, a "colored laundry girl carrying laundry basket in regulation manner," 1898–1899. This photograph appears to have been taken next to Greenville's First Presbyterian Church on Richardson Street at West Washington Street. (Courtesy of the C. L. Baley Collection, Schomburg Center, New York Public Library.)

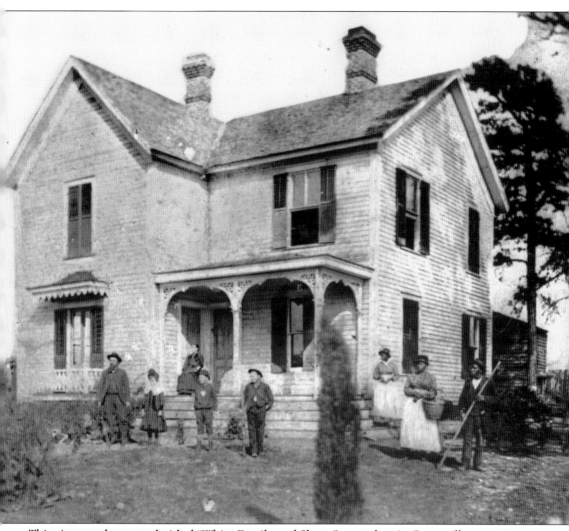

This vintage photograph titled "White Family and Slaves" was taken in Greenville sometime before the Civil War. The white family is seen at the front of the house, while the slaves are staying in their place, at the side or rear. (Courtesy of the Coxe Collection, Greenville Historical Society.)

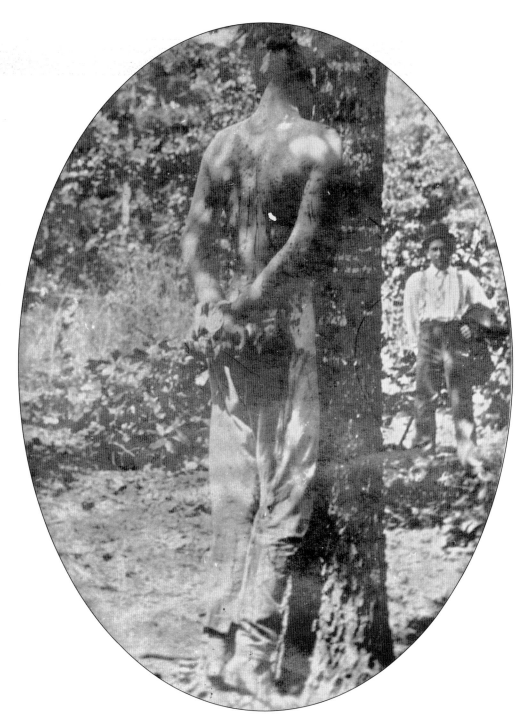

This photograph from the C. L. Baley Collection is an original print. This image shows an African American man bound and whipped. The photographer captures the appearance of fresh wounds, which appear to be dripping with blood. This image reflects a shameful period in Greenville in the late 1800s. (Courtesy of the C. L. Baley Collection, Schomburg Center, New York Public Library.)

Two

INDUSTRIOUS LABORERS

After the Civil War, many freedmen and women left their former enslavers. Many scoured the Upstate, taking advantage of newfound opportunities to advance themselves as freedmen and women by opening their own businesses or marketing their own services to help rebuild the war-torn economy. According to Mathis's research, there were more than 70 African American businesses in Greenville with sizeable assets. There were African American railway brakemen, mail carriers, plumbers, cotton samplers, 15 blacksmiths, 10 carpenters, 6 brick masons, 4 painters, 4 shoe makers, stevedores, 2 harness makers, 3 tinsmiths, 3 tanners, 4 painters, 8 draymen, 3 barbers, 4 seamstresses, 2 tailors, 3 retail grocers with inventory in excess of $2,500, a streetcar conductor, a wagon maker, and 2 barroom owners in the 1870s. George Benson and Allen Maxwell had blacksmith shops downtown with assets over $1,500. W. J. Pressley, Clark Smart, Thomas Lewis, William Sloan, Willie Brinks, and Watson Kilgore also owned blacksmith shops. Mathis's research revealed the names of several African American businessmen in the 1860s: James Herron was a cotton sampler; Fred Robertshaw was a wagon maker; Cornelious Holloway had a general store; Allen Robinson of 1 Echols Street was a mail carrier; and Henry Mosley had a brick manufacturing business on West Washington Street Extension. By 1880, there were five African American barbershops and one restaurant, owned by Thomas Frazier. William Fronsberger was thought to be the first African American streetcar conductor. Two barroom operators, Zion Collins and George Howard, were located on Augusta Street. Greenville was a mill town; however, only about 10 percent of African Americans were allowed to work in prestigious manufacturing jobs in the mills.

Wilson Cooke is recognized as a founding father of Greenville. Cooke was brought to Greenville as a slave by Vardry McBee. He worked hard, saved his money, and bought his freedom. He opened a general store and a tannery. By 1881, Wilson Cooke was one of the highest taxpayers in Greenville County. After the Civil War, Cooke served in the South Carolina Radical Legislature from 1868 to 1870 when African Americans, controlled the state legislature and crafted legislation for state funding of public education and other matters of importance to elevate the state. (Courtesy of David Ezell Henry.)

This is a sketch of Dudley Talley, a wealthy former slave who controlled much of the draying and hacking business in Greenville during the Reconstruction period. (Courtesy of David Ezell Henry.)

This photograph, "African American Thruston Family Mammy," symbolizes proud black domestics during the 1800s and 1900s. These proud women were seen with forced smiles and sad eyes. Long hours with low pay meant leaving their own families behind to cook, iron, and care for the homes and children of employers. Their meager pay helped to feed and clothe their own family while contributing to the growth of schools, churches, and early colleges. (Courtesy of the Greenville Historical Society.)

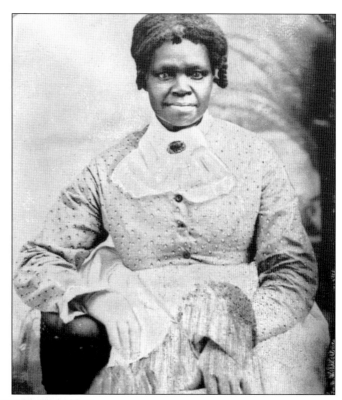

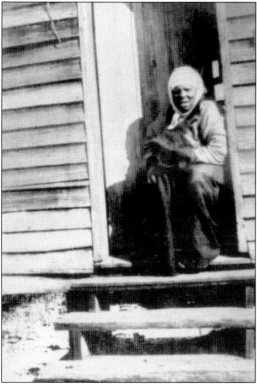

Aunt Betty, a former slave, sits in the doorway of her cabin behind the home of a white family on Rutherford Road. Aunt Betty may have sat in her doorway to get a breath of air or to be ready when her employer beckoned her with a wave of a hand or the ringing of a bell. (Courtesy of Carolina First, South Carolina Room, Greenville County Library System.)

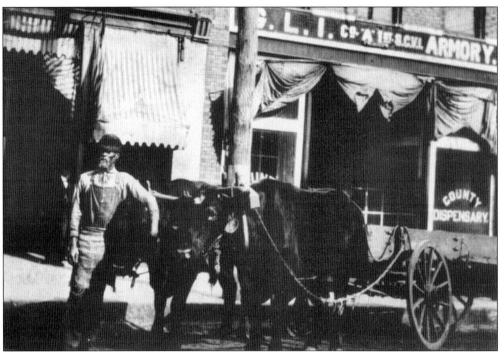

This is an image of a black man and oxen outside the county dispensary in Greenville. Draying and hacking to haul produce was a common occupation for black men in the mid-1800s. (Courtesy of the Coxe Collection, Greenville Historical Society.)

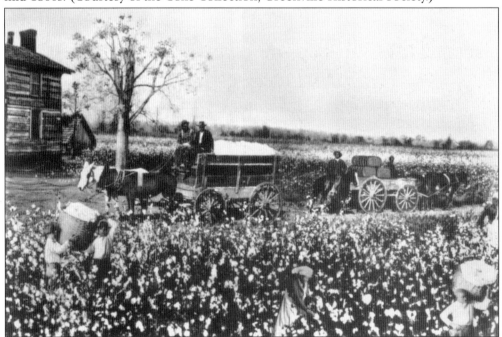

This is a vintage image of workers and overseers in a Greenville cotton field. Wagons are filled with cotton, while pickers with baskets and cotton sacks are working from a white sea of cotton stalks. (Courtesy of the Coxe Collection, Greenville Historical Society.)

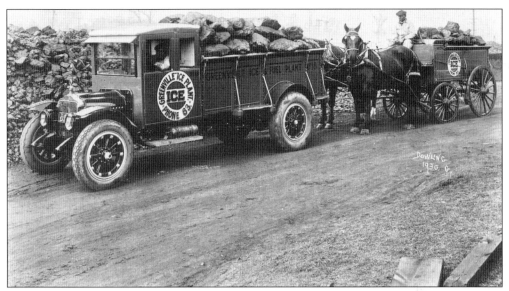

This is a vintage image of black workers at the Greenville Ice Plant. This 1930 photograph has a horse-drawn wagon filled with wood and coal following a truck that shows the company two-digit telephone number, 83. (Courtesy of the Coxe Collection, Greenville Historical Society.)

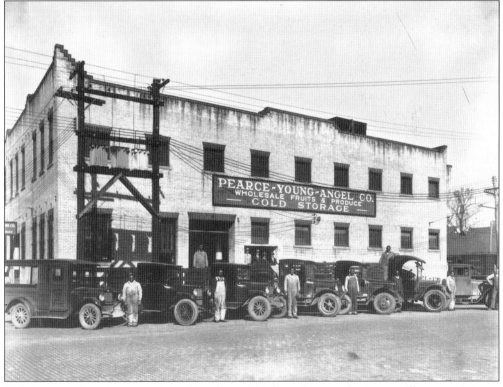

This image, taken in the early 1900s, shows black workers at the Greenville Pearce Young Angel Company (PYA). PYA specialized in providing wholesale fruit and produce, as well as in cold storage. (Courtesy of the Coxe Collection, Greenville Historical Society.)

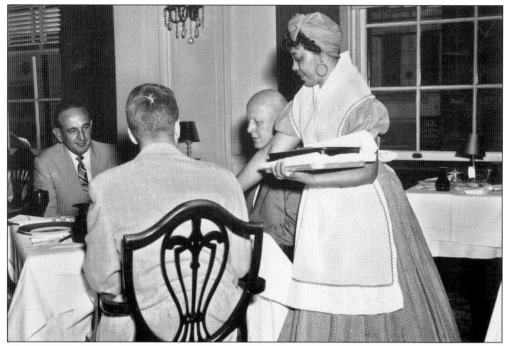

This photograph was titled "Negro Mammy Serving Spoon Bread at the Poinsett Hotel." All-white diners enjoy all the ambiance of the Old South in the emerging New South of the mid-1900s. (Courtesy of the Coxe Collection, Greenville Historical Society.)

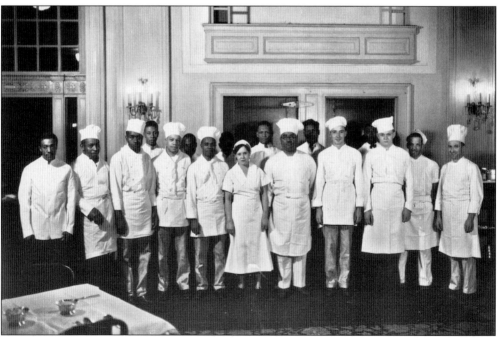

The diversity seen in this photograph of the Poinsett Hotel staff during the period of segregation was in stark contrast to the times. (Courtesy of the Coxe Collection, Greenville Historical Society.)

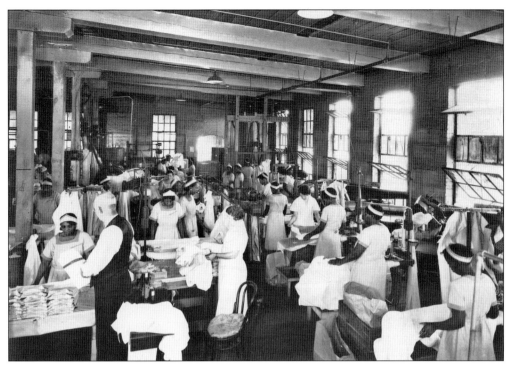

Black and white Ideal Laundry workers laboring side by side during the period of Jim Crow demonstrate the economic pressures that drove selected segregation. (Courtesy of the Coxe Collection, Greenville Historical Society.)

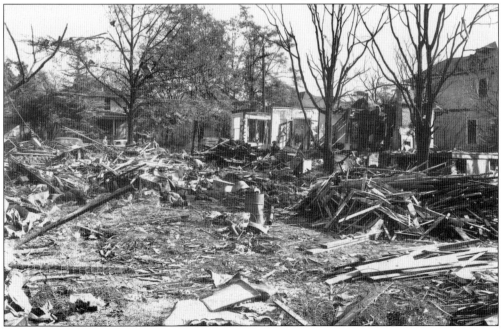

A horrific explosion and fire destroyed the Ideal Laundry during the 1950s. Many workers of both races were killed. This is a photograph of the Ideal Laundry after the fire. (Courtesy of the Coxe Collection, Greenville Historical Society.)

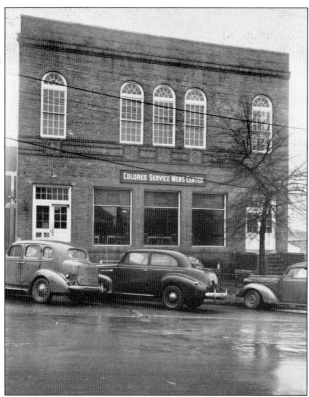

The African American USO Center for servicemen in the late 1940s was once a prominent black-owned building on the corner of Fall and Broad Streets in downtown Greenville. This building was constructed by the Working Benevolent Temple. (Courtesy of the Coxe Collection, Greenville Historical Society.)

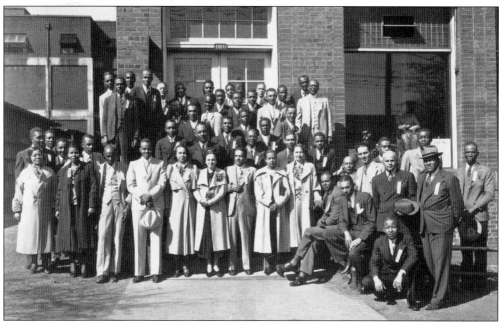

Members of the South Carolina Negro Life Association in the 1930s represented a sizeable number of black professionals during the age of Jim Crow. Insurance agents and collectors were trained to help the community become aware of the need to prepare for the final needs of their family. (Courtesy of the Coxe Collection, Greenville Historical Society.)

The third meeting of the South Carolina Negro Life Association was held in Greenville. This photograph depicts the professional presence of three black businessmen who were self-employed as insurance agents and collectors during the late 1930s. (Courtesy of the Coxe Collection, Greenville Historical Society.)

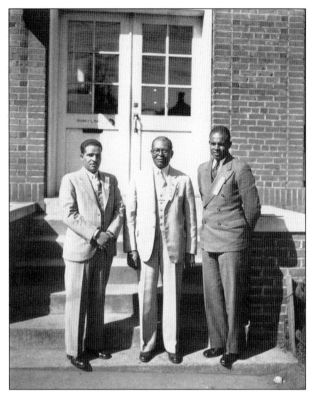

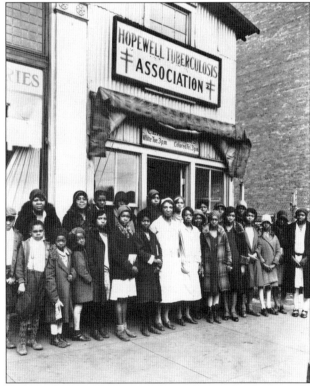

Trained black nurses and volunteers are pictured with their patients at the front of the old Hopewell Tuberculosis Hospital. (Courtesy of the Coxe Collection, Greenville Historical Society.)

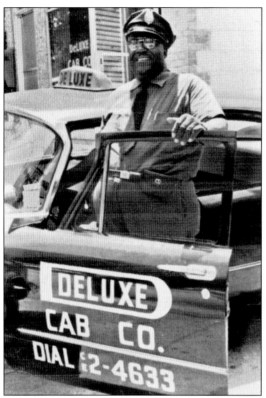

Mack Jones, owner of Deluxe Taxi Company, was another black business owner who served the needs of the black community in Greenville during the late 1940s. Deluxe Taxi was one of many black-owned businesses that once thrived on East McBee Avenue. (Courtesy of John Wesley Jones Collection.)

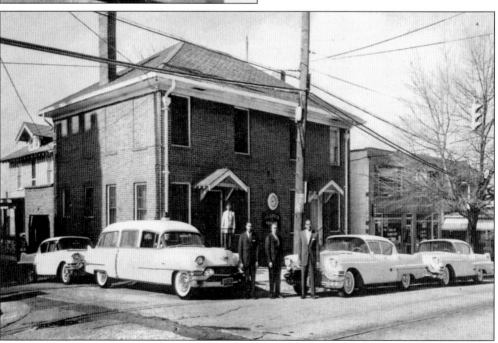

Clark's Funeral Home was once located on East McBee Avenue in Greenville, near Springfield Baptist Church, black residences, and a host of black businesses that thrived downtown before the 1970s. (Courtesy of Clark's Funeral Home, Dr. Ann Pinson.)

S. C. Franks was a businessman and a community servant. The S. C. Franks Chapel of Remembrance was organized in 1935 by Franks in a small house on East McBee Avenue. Franks attended Sterling High School and became a pioneer in the South Carolina Morticians Association. A former agent with the Pilgrim Health and Life Insurance Company, Franks never said no to families in times of bereavement. He was a dedicated community servant, often volunteering his funeral cars to transport people. (Courtesy of Dawn Franks Davis.)

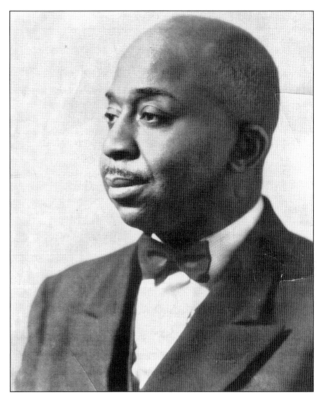

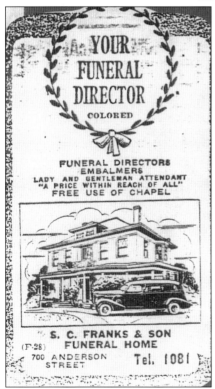

This S. C. Franks and Son Funeral Home card, "Your Funeral Director—Colored," promoted business. (Courtesy of Dawn Franks Davis.)

Webb Funeral Home was founded by L. Dutt Webb and his wife, Essie Settles, in 1941 at 411 East McBee Avenue. They had previously owned the McBee Avenue Café at the corner of McBee Avenue and Mordecai Street. In 1972, property was purchased at 552 West Washington Street. Their only child, Robert "Bobby" Webb Settles, has maintained the legacy of Webb's. He retired from the military in 1975 and returned home to help his mother run the business after his father's death. The name was later changed to Webb-Settles Funeral Home, Inc. Renovations were completed in 1981 and in 1999 under his leadership. (Courtesy of Robert Webb Settles.)

Three

THE SCHOOLHOUSE DOORS

Mathis's research indicates that after the Civil War, African American parents were determined that their children would have the opportunity to attend school. During this period, "as fast as any kind of teacher could be secured, not only were day schools filled, but night schools as well." The aura of the all–black schools was excellence in scholarship, character, leadership, and service. Many churches formed schools in the 1920s. Fuller Normal Industrial Institute moved to Greenville on October 12, 1923. Bishop William Edward Fuller Sr., father and founder of the Fire Baptized Holiness Church of God of the Americas, had a God-inspired vision of a school to educate African American children. Fuller Normal has never abandoned its goal of teaching the basic skills and spiritual values to students in Greenville, many of whom were suspended or expelled from the public school system. The Franciscan Friars and Sisters of St. Anthony of Padua started St. Anthony of Padua School for African American students in the parish as well as any other interested families of the neighborhood in the early 1950s. For more than 50 years, St. Anthony of Padua has educated African American children from pre-kindergarten through grade five with excellence in academics and few if any discipline problems. With the coming of school integration, all–black schools were closed or converted to centers, and one school burned. The excellence has been replaced by a tremendous gap in academic achievement among African American students, and African American teachers, counselors, coaches, and administrators slipped from 20 to 24 percent to less than 10 percent.

The Allen School, above, closed during the period of school desegregation. The historic school building sits abandoned on Cemetery Street in downtown Greenville. (Courtesy of the Oscar Landing Collection, Greenville Historical Society.)

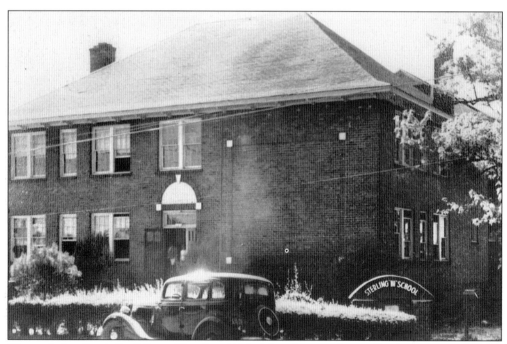

The early Academic Building of Sterling High School was a place of high expectations and learning. (Courtesy of the Oscar Landing Collection, Greenville Historical Society.)

Parent involvement flourished during the period of segregation. Parents attended PTA gatherings to secure information, meet teachers, follow up on their children, and socialize informally. (Courtesy of Lawrence Acker.)

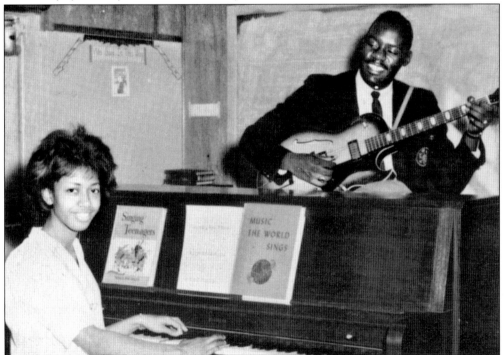

Myrtle Hall and Moses C. Dillard are two talented Sterling High School students who achieved fame. Myrtle Hall, a lyric soprano, performed all over the globe with the Billy Graham Crusade. Moses Dillard, a musical virtuoso, collaborated with Al Green on a Grammy-winning album. He was a songwriter, publisher, producer, and record-industry executive. (Courtesy of Lawrence Acker.)

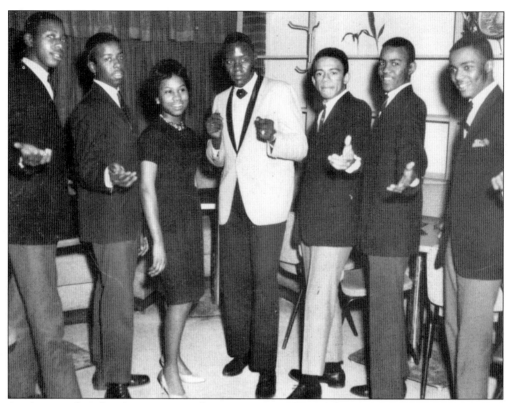

Sterling High School's Dynamic Showmen were, from left to right, Preston Robinson, trumpet; Leo Adams, drums; Teresa Simmons, vocalist; Moses Dillard, guitar; Garland Taylor, vocalist; Henry Dillard, saxophone; and Reginald Avery, bass guitar. (Courtesy of Lawrence Acker.)

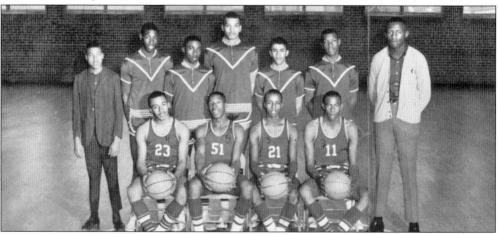

Sterling basketball stand-outs are, from left to right, as follows: (seated) Phillip Thompson, John Fisher, James Baily, and Jerry Latimore; (standing) trainer Charles Mattison, Johnny McNeil, Jimmy Suswell, Lawrence Acker, Thomas White, William Thompson, and trainer James Rendrick. Several Sterling athletes later played for professional teams in the NBA and NFL with the skills they acquired at Sterling High School. (Courtesy of Lawrence Acker.)

This is a 2006 photograph of the old Washington High School. The school operated for eight years, 1962–1970, before desegregation occurred in Greenville. The principal was J. Wilbur Walker. (Courtesy of Leola Robinson-Simpson.)

Fuller Normal Industrial Institute was moved to Greenville on October 2, 1923, by the Fire Baptized Holiness Church of the Americas to ensure the teaching of academics and spiritual values. The founder is Bishop W. E. Fuller Sr. Students are immersed in academics, character education, and biblical teachings. (Courtesy of Fuller Norman Industrial School.)

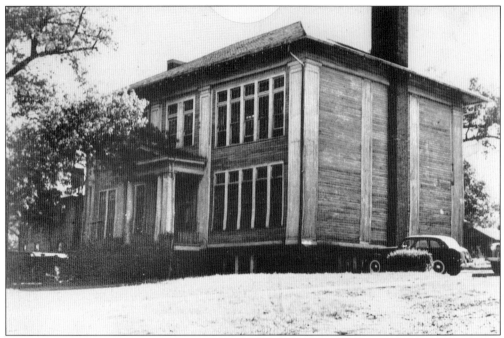

Union School on Markley Street in the West End served students eager to learn and teachers eager to teach. (Courtesy of the Oscar Landing Collection, Greenville Historical Society.)

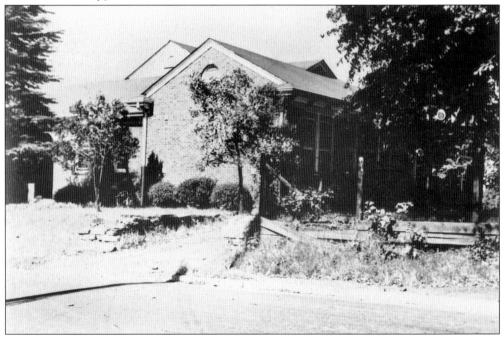

Oscar Street School was a small school off Hudson Street and West Washington Street that educated elementary school children in primary grades one through three. Oscar Street School was closed and demolished during the desegregation era. (Courtesy of the Oscar Landing Collection, Greenville Historical Society.)

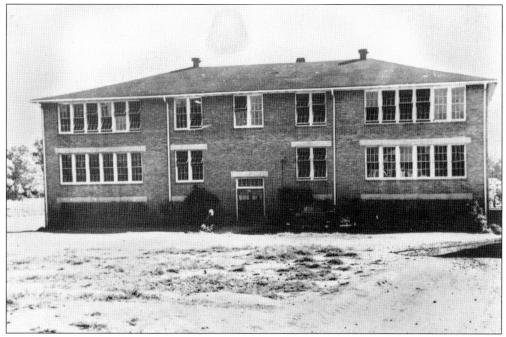

Sullivan Street Elementary School served students in the Augusta Road perimeter. With integration, Sullivan Street Elementary School was converted to a district book center and alternative school for students with disciplinary infractions. (Courtesy of the Oscar Landing Collection, Greenville Historical Society.)

St. Anthony of Padua School, "Keeping hope alive since 1951," was founded by the Franciscan Friars of Holy Name Province and the parishioners of St. Anthony of Padua Catholic Church to serve the children of the parish as well as other children in the Gower Street community. St. Anthony Catholic School has educated generations of children with high expectations and amazing results. (Courtesy of St. Anthony of Padua School.)

This is a 2006 photograph of the closed Lincoln High School building. Lincoln High School operated from 1954 until 1970 to serve black students in the upper part of Greenville County until the year of court-ordered desegregation. (Courtesy of Leola Robinson-Simpson.)

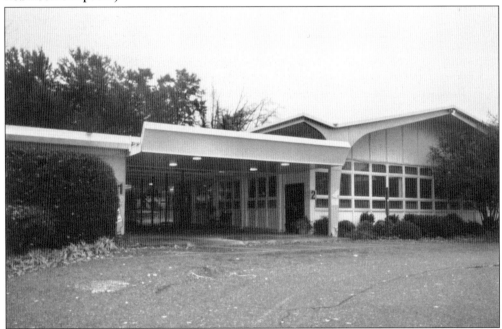

This is a 2006 photograph of a part of the old Bryson building. Bryson High School operated from 1954 until 1970 to serve black students in the lower part of Greenville County until the year of court-ordered desegregation. Dr. A. M. Anderson was principal during the entire history of the school. (Courtesy of Leola Robinson-Simpson.)

Joseph E. Beck High School was added as a high school to serve students in the Nicholtown and Fieldcrest areas of the city in 1965. The school was converted to a middle school in 1970, having operated for only four years. The principal was Lemmon Stevenson and the assistant principal was Albert A. Richburg. The motto was "Service, Simplicity, Sincerity." (Courtesy of Leola Robinson-Simpson.)

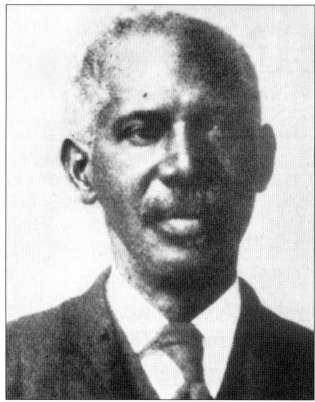

Dr. D. M. Minus was the first principal of Sterling High's forerunner, Greenville Academy, in 1902. He was also pastor of John Wesley United Methodist Church from 1889 to 1902. (Courtesy of the Greenville Cultural Exchange Center.)

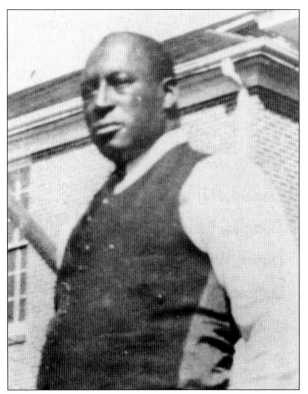

Prof. R. L. Hickson was principal of Sterling High from 1930 to 1940. The charismatic Professor Hickson commanded the love and respect of students, faculty, and staff. His high expectations set the tone for scholarship, leadership, and exemplary behavior at school and in the community. (Courtesy of the Greenville Cultural Exchange Center.)

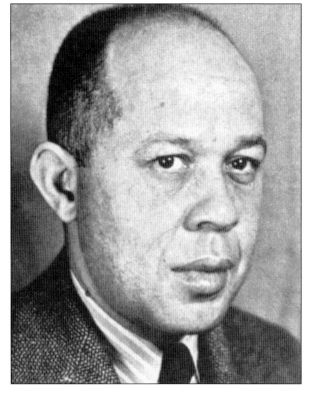

Joseph E. Beck was the beloved Sterling principal from 1940 to 1961. Sterling grew under his leadership. When Sterling students launched protests downtown in 1960, Beck was called to task by the mayor. A fearless and proud black man, Beck responded, "I run Sterling—not Main Street." Beck passed away after a brief illness. (Courtesy of the Greenville Cultural Exchange Center.)

Rev. H. O. Mims, Sterling High School principal from 1961 to 1968, took Sterling's helm after the death of Principal Joseph E. Beck and continued the Sterling legacy of excellence. Reverend Mims loved Sterling, and he loved Sterling students and encouraged many students to attend college. (Courtesy of the Greenville Cultural Exchange Center.)

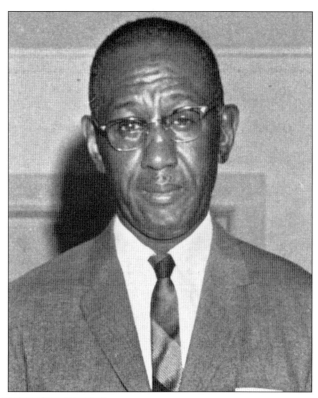

Luke Chatman was the last principal of Sterling High School. He was principal from 1968 until school desegregation on February 17, 1970. He promoted the great legacy of Sterling High School. He prepared students and staff for a smooth transition into desegregation and the closing of Sterling. (Courtesy of the Greenville Cultural Exchange Center.)

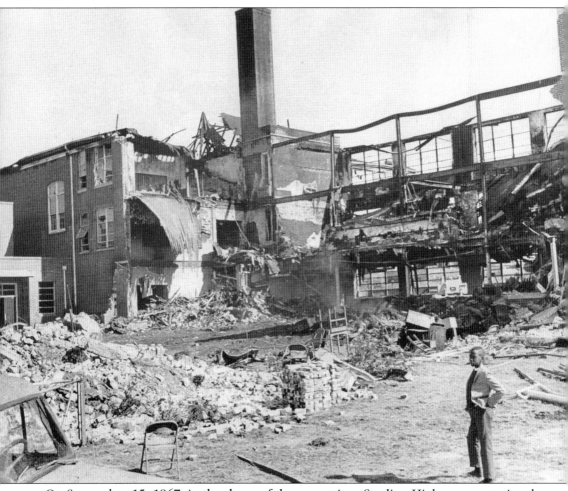

On September 15, 1967, in the dawn of desegregation, Sterling High was mysteriously destroyed by fire. This image shows the school in ruins after the fire. (Courtesy of the Greenville Cultural Exchange Center.)

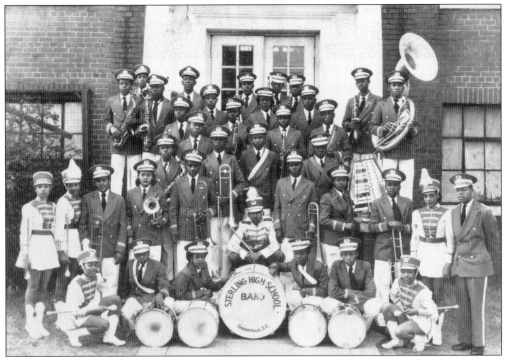

The widely acclaimed Sterling High School Band climaxed the Annual Greenville Christmas Parade with the magnificent sound of the band and the sight of the high-stepping majorettes whirling their batons. (Courtesy of Ruth Watkins-Smith collection.)

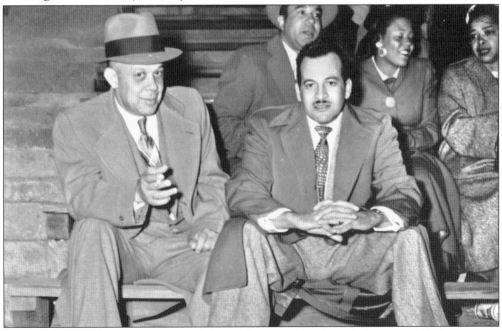

The Sterling High School principal from 1940 to 1961, Joseph E. Beck, left, is pictured with friends and supporters at a Sterling High School football game. (Courtesy of the Robert Bradford Collection.)

Teachers from local African American schools attended Sterling football games in support of their students and former students. (Courtesy of the Robert Bradford Collection.)

The faculty at Sullivan Street School, led by principal Edgar G. Grimes, was a dedicated team of educators. (Courtesy of the Robert Bradford Collection.)

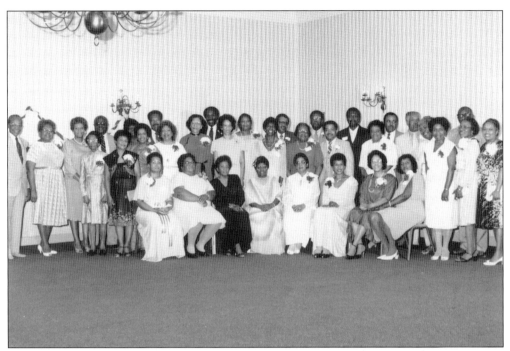

A reunion of Sterling High students and teachers from the class of 1951 brings together beloved retired teachers and their now-adult former students. (Courtesy of the Robert Bradford Collection.)

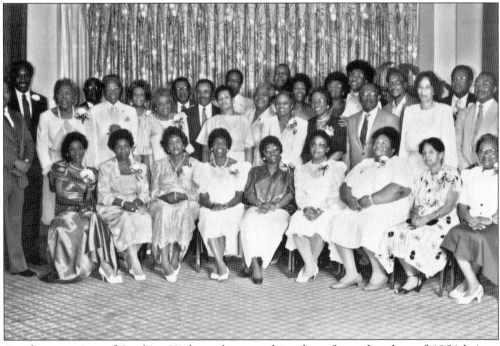

Another reunion of Sterling High students and teachers from the class of 1951 brings together additional beloved retired teachers and their now-adult former students. (Courtesy of the Robert Bradford Collection.)

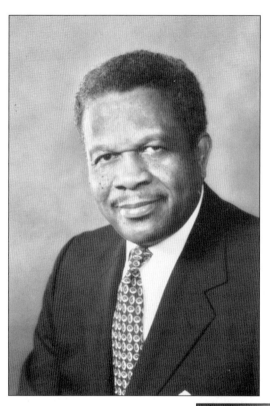

Greenville native Dr. Thomas Elliott Kerns, a graduate of Sterling High School, was the first black superintendent of schools in Greenville County, the largest school district in the state and the 64th largest public school system in the country. Dr. Kerns served as superintendent from 1989 to 1994. (Courtesy of Dr. Thomas E. Kerns.)

Dr. Rudolph G. Gordon was the second black superintendent of Greenville County schools, serving from 1996 to 2000. Prior to being named superintendent, Dr. Gordon served as the interim superintendent and brought to the job 40 years of experience with the district. (Courtesy of Dr. Rudolph G. Gordon.)

Dr. Phinnize Fisher was named the third black superintendent. She also has the distinction of serving as the first woman superintendent of Greenville County Schools in 2004. She previously served Greenville County as assistant superintendent of middle school education from 1996 to 1998 and chief of staff from 1998 to 2004. (Courtesy of the School District of Greenville County.)

Joseph Vaughn, a Sterling High School graduate, was the first black graduate of Furman University. He was a gifted teacher and a leader in the State Teacher's Association. (Courtesy of Laurence Acker.)

On October 2, 1923, Bishop William Edward Fuller Sr. founded the Fuller Normal Industrial Institute in Greenville. (Courtesy of the Fuller Normal Industrial Institute.)

Rev. Joseph D. Mathis, beloved Sterling High School teacher and coach, was a city councilman, historian, and pastor of Young Laymen CME Church. He was a respected role model for youth, inspiring many to greatness. (Courtesy of Laurence Acker.)

Four

THE BLACK CHURCH

In Greenville, African American servants and free persons of color were allowed limited membership in white Baptist, Methodist, and Presbyterian churches, according to the research of Joseph D. Mathis. Mathis found that on January 17, 1856, the Greenville City Council decreed that "slaves and free persons of color shall be allowed to assemble at any of the churches of the town for the purpose of religious worship three times each week and not elsewhere or oftener; provided that all such meetings some respectful white citizen of the town be and remain present during such meetings." According to *We Are a Part . . .* , Jubilee Baptist Church on Rutherford Road in Taylors, founded in 1864, has the distinction of being the oldest African American church in the Piedmont. Rev. James R. Rosemond is highly regarded as a pioneer of the black churches in Greenville. Rosemond established more than 17 Methodist churches in Greenville County during the 45 years of his ministry. The church was a rock in a weary land for African Americans up from slavery. Matoon United Presbyterian Church, located in the Hampton-Pinkney Historic Preservation area of the city, is the oldest African American church building still standing in Greenville. The cornerstone of the present building was laid in 1887. Some of the bricks were made by freedmen. In the early 1890s, members of the Olive Christian Methodist Church formed a Christian Methodist Episcopal (CME) church called Israel Chapel on Birnie Street. The present Israel Metropolitan CME Church was built on Calhoun Street in 1919. The House of Prayer in Greenville, founded by Bishop Charles Manuel "Sweet Daddy" Grace, and the Holiness Churches of the Apostolic Faith also swelled in membership. The spirited radio program *Meeting House in Dixie* drew many unbelievers into the fold during the 1950s.

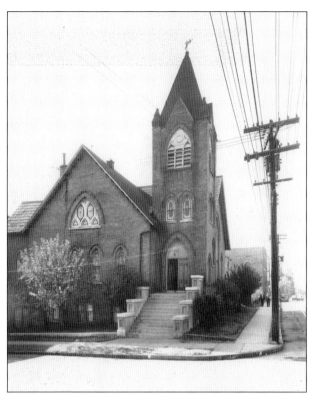

John Wesley United Methodist Church was founded in 1866, as the Silver Hill Methodist Church. The first church, located on Ann Street, moved in 1862 to Cleveland and Choice Streets, until the present building was constructed on Fall Street. The church was founded as the Silver Hill Methodist Church, North, by Rev. James Rosemond, a slave of Waddy Thompson, a Greenville judge, and later Vardry McBee. (Courtesy of the Greenville Historical Society.)

Allen Temple African Methodist Episcopal (AME) Church was established in 1875 in downtown Greenville after the Civil War. The church bought the old Gaillard School chapel at the triangular corners of Green Avenue, Markley Street, and Vardry Street in 1881. There the church opened a school for black children and the Allen Temple African Methodist Episcopal Church. The current bricked building is said to have been bought with funds donated by the congregation and by selling bags of peanuts. The church has added a state-of-the-art community development center. (Courtesy Allen Temple AME Church.)

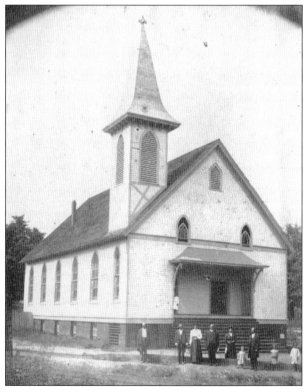

Dr. S. C. Cureton, pastor of the Reedy River Missionary Baptist Church, is a great South Carolinian. The new Family Life Center at Reedy River expands and strengthens community outreach activities to serve the needs of families. Standing tall, he wisely guided the largest black organization in America, the National Baptist Convention, USA, Inc., in 1999, during a period of controversy. He also served as president-at-large from 1994 to 1999 and led the Baptist Educational and Missionary Convention of South Carolina, the largest black organization in the state. He is a man of God, an educator, a civil rights activist, and a respected community leader. (Courtesy of Reedy River Baptist Church.)

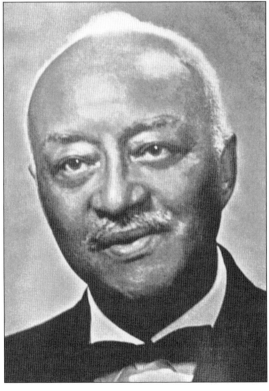

Rev. John Henry Smith (1890–1989), a Jefferson Award winner, is a legend. He built and pastored Jubilee Baptist Church, Bruton Temple Baptist Church, and Mountain View Baptist Church. He was a pioneer of self-help, establishing and publishing three black newspapers—the *Human Christian Association Bulletin*, the *Greenville World*, and the *Southern Crusader*—which provided jobs. He also organized and founded four businesses: Liberty Real Estate Company, the People's Benefit Society, Southside Rescue Mission for blacks, and the Mountain View Day Care Center. (Courtesy of Mount View Baptist Church.)

Rev. Sylvester Golden is pastor of the Piedmont Manor Baptist Church and the Golden View Baptist Church. His radio ministry on WPJM 800 and television ministry on channel 16 WGGS bring the gospel to thousands each week. His calling is also feeding the hungry with salvage grocery items that he has distributed weekly from the back of an old, refurbished school bus, called the "Miracle Bus," since 1986. His weekly visits have the hungry waiting for his Miracle Bus to appear. Reverend Golden has received many Jefferson Award nominations. (Courtesy of Piedmont Manor Baptist Church.)

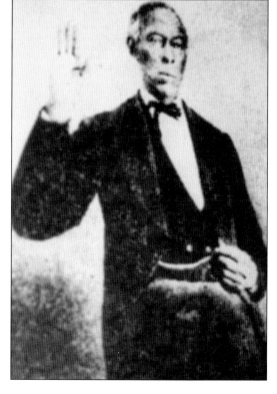

Rev. Gabriel Poole was the first pastor of Springfield Baptist Church. He and his wife, Anna, were among 65 members of First Baptist Church who had grown weary of sitting quietly in the balcony. In 1867, their request for dismissal and aid was granted, and Springfield Baptist Church was founded. In 1970, a small wooden church was erected on East McBee Avenue on a lot donated by Alexander McBee. (Courtesy of Lottie B. Gibson.)

Rev. D. C. Francis (left) receives a copy of the framed record of the minutes granting the African American members permission to organize Springfield Baptist Church in 1867. Rev. Herbert Sergeant (right), then acting pastor of the First Baptist Church, is presenting. (Courtesy of Lottie B. Gibson.)

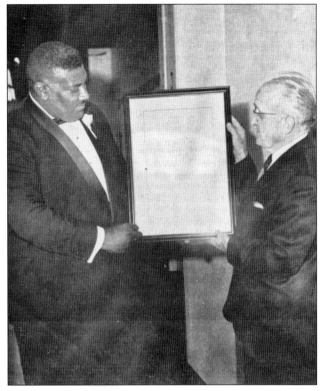

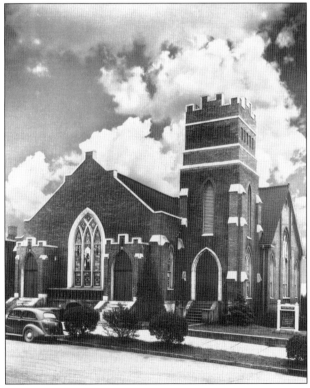

Springfield Baptist Church was the headquarters for the civil rights movement in the 1960s under the leadership of the Reverend James S. Hall, 1957–1963, and the Reverend D. C. Francis, 1963–1973. This historic edifice was mysteriously destroyed by fire in 1972. A beautiful new church was dedicated in December 1976 under the leadership of Dr. John H. Corbitt, pastor since 1974. (Courtesy of the Coxe Collection, Greenville Historical Society.)

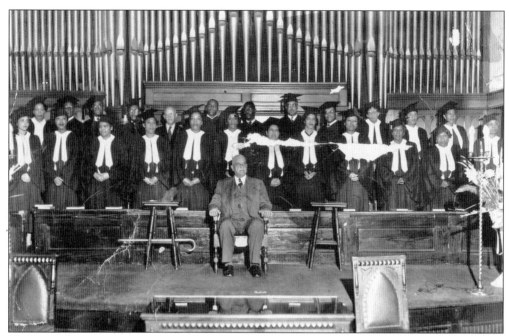

This image is a nostalgic reminder of worship at the old Springfield Baptist Church, which was destroyed by fire in 1972. The Reverend Charles S. Gandy, pastor from 1914 to 1956, the choir, and the pipe organ can be seen in the background. (Courtesy of Ruth Watkins-Smith.)

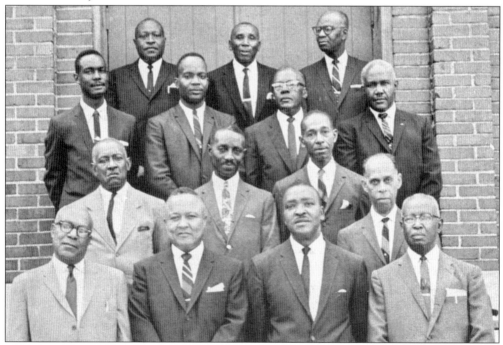

Captured in this photograph of the Springfield Trustee Deacon Board in 1967 are many of the educators and business leaders in Greenville's history. (Courtesy of Lottie B. Gibson.)

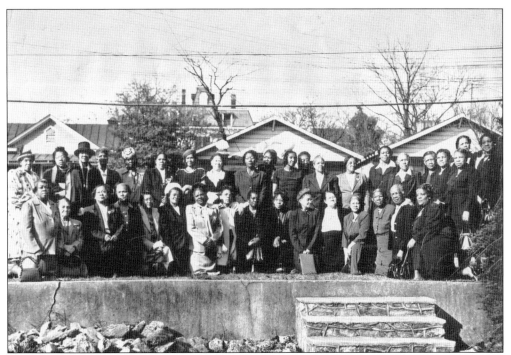

Springfield Baptist Church was once the center of black homes and businesses. In this 1950s photograph, church missionary members pose in the lot adjoining the church. Residences are seen in the background. (Courtesy of Ruth Watkins-Smith.)

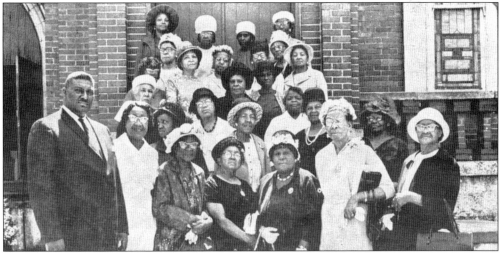

Captured in this photograph are the images are many of the leading African American women who worked in the church and community during their lifetimes. They were members of the Springfield Baptist Church Senior Missionary Society of 1967. (Courtesy of Lottie B. Gibson.)

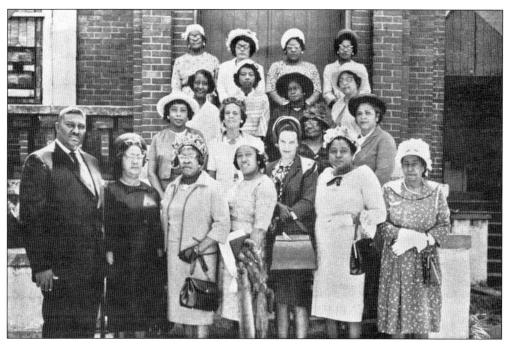

This photograph of the Belle V. Gandy Missionary Society of 1967 captures some of the leading women educators and church leaders during that time. (Courtesy of Lottie B. Gibson.)

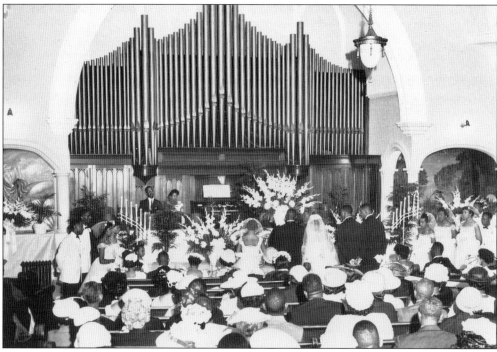

The memories of a church wedding in the black church are unforgettable. This is a 1950s-era wedding at Springfield Baptist Church on East McBee Avenue. The flowers are still beautiful. (Courtesy of Ruth Watkins-Smith.)

Five

HOUSING
THEN AND NOW

The research of Joseph D. Mathis indicated that in 1790 there were nine free African Americans, 606 enslaved, and 5,888 whites in Greenville. However, by 1860, before the Civil War, there were 212 free African Americans, 7,049 enslaved, and 14,631 whites in Greenville. Although African Americans were denied civil and human rights, they managed through personal sacrifice and thriftiness to own personal property. Freedmen in Greenville were allowed to buy their homes and additional land from their former owners with extra money saved through their industriousness. Mathis reported that in 1880, an article in the *Greenville Enterprise* newspaper revealed that African Americans in Greenville led the state in ownership of homes and farms. The *Greenville Daily News* on January 8, 1881, reported that "twenty-one colored men in Greenville pay taxes ranging from $200 to $2,300 on real and personal property." African Americans saw land ownership as a means of freedom and independence, and they bought acres and acres of land to pass on to their heirs to ensure their future in Greenville.

Today many of the old African American neighborhoods have gone without a trace of their prior existence. The present industrial and commercial area around Woodruff Road, Roper Mountain Road, Haywood Road, and Lownes Hill Road was thriving black farmland during the 1920s. Red Hill was located downtown on Brown Street, which is now the present-day site of the Hyatt Hotel. Red Hill was home to a thriving upper- to middle-income black community. Little Texas was a poor but thriving and proud African American neighborhood downtown. Dirty Thirty consisted of 30 houses on Springer Street at the rear of Haynie Street and Howe Street, a few short blocks from the old downtown campus of Furman University. The County Redevelopment Authority and the City of Greenville have rebuilt homes in many neighborhoods.

Viola Street was home to many blacks growing up in Greenville from the early 1900s until the mid-1980s. Racial segregation limited the options for decent housing. The City of Greenville, in partnership with the Greenville Urban League, made a commitment to rebuild Viola Street. (Courtesy of the City of Greenville, Community Development Department.)

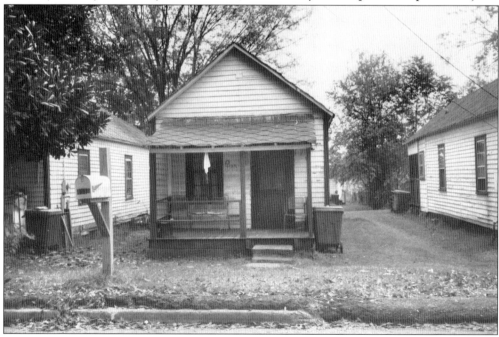

This house on Oscar Street is relic of a bygone era when Oscar Street School served neighborhood children. Many of these shotgun houses rented for $10 per week in the 1960s. (Courtesy of the City of Greenville, Community Development Department.)

Parker Circle, now revitalized by the city of Greenville, was another street in Greenville that was once a well-populated neighborhood for blacks from the beginning of the 20th century. Many blacks occupied these homes until the late 1990s. (Courtesy of the City of Greenville, Community Development Department.)

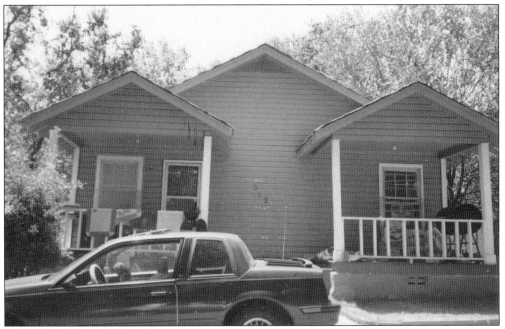

This is a photograph of an old duplex house on Haynie Street. Many well-known Greenvillians lived on Haynie Street. Hattie Logan Duckett and her sister Ella Mae Logan were two respected educators who lived on Haynie Street. (Courtesy of the City of Greenville, Community Development Department.)

This is a scene from a street in an old neighborhood. Curbs and sidewalks were rare in black neighborhoods. (Courtesy of the City of Greenville, Community Development Department.)

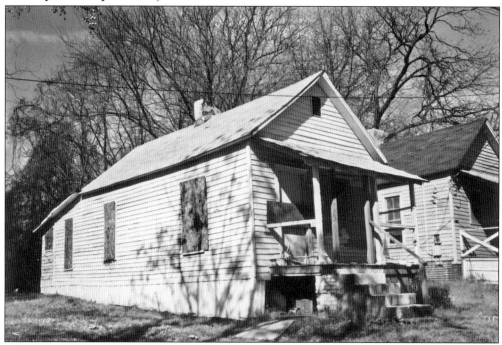

This house at 12 Robbins Street off Dunbar Street was a part of the thriving Green Avenue community up to the new millennium, when neighboring streets were closed for the expansion of Greenville High School. (Courtesy of the City of Greenville, Community Development Department.)

This area, now revitalized by the City of Greenville, was also once a well-populated neighborhood for blacks from the beginning of the 20th century. (Courtesy of the City of Greenville, Community Development Department.)

During the 1950s, Meadow Street was a well-known street and the home of the old Harlem Theater for blacks. (Courtesy of the City of Greenville, Community Development Department.)

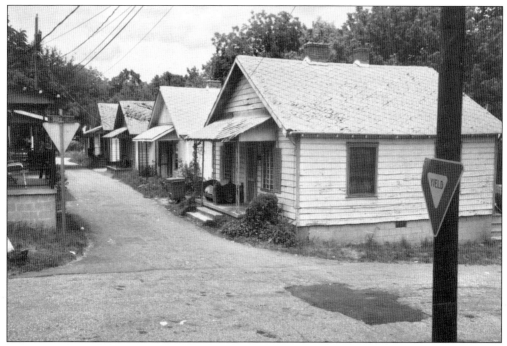

Dewey Street is another street that has been revitalized by the City of Greenville. Dewey Street had houses with steps that reached to the street with no front-yard space. (Courtesy of the City of Greenville, Community Development Department.)

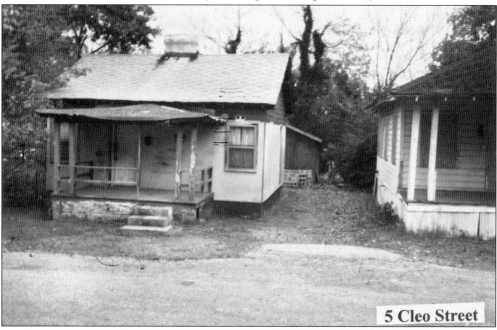

Cleo Street has also been revitalized by the city after years of occupancy by African Americans. Streets in black neighborhoods often lacked curbs and sidewalks. Repairs by slum landlords were rare. (Courtesy of the City of Greenville, Community Development Department.)

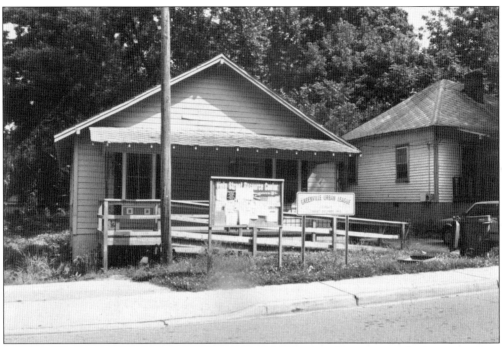

The old Viola Street Urban League Center has been replaced with a new facility. (Courtesy of the City of Greenville, Community Development Department.)

The new Viola Street Center is an up-to-date facility for the community. (Courtesy of the City of Greenville, Community Development Department.)

This house on Dunbar Street was built by the city. (Courtesy of the City of Greenville, Community Development Department.)

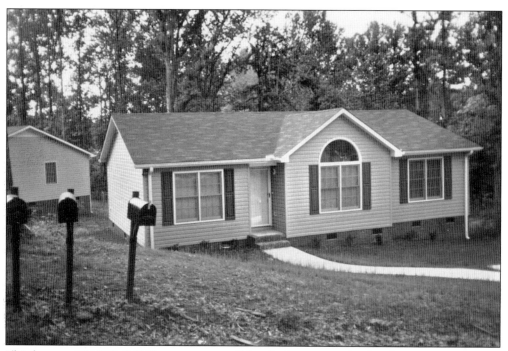

This house at 315 High Valley was a part of the city's community-development initiatives. (Courtesy of the City of Greenville, Community Development Department.)

The city's revitalization efforts
have a tremendous impact
on the lives of black children.
In this scene, black children
are drawn to the ice-cream
truck. (Courtesy of the City
of Greenville, Community
Development Department.)

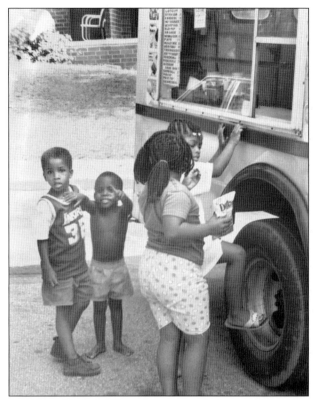

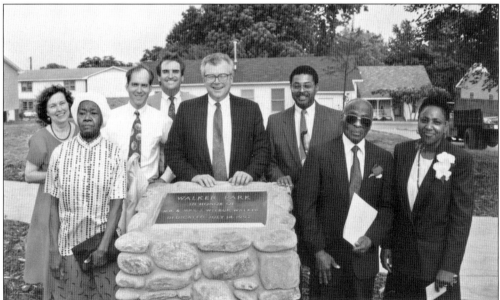

This is a scene from the dedication of Walker Place. Walker Place was named in honor of
Wilbur Walker, a proud neighborhood resident who served as a respected principal at the
all-black Washington High School. Wilbur Walker was loved by many in the community for
his leadership when he was a principal. (Courtesy of the City of Greenville, Community
Development Department.)

This image is an example of the beautiful, new, affordable homes on Viola Street that were developed by the City of Greenville and the Greenville Urban League. (Courtesy of the City of Greenville, Community Development Department.)

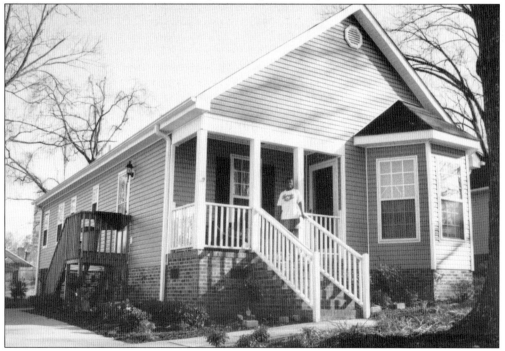

This image is another example of the homes on Viola Street that were developed by the City of Greenville and the Greenville Urban League. (Courtesy of the City of Greenville, Community Development Department.)

Six

SOCIAL LIFE
AND FUND-RAISING

During the 1800s, African Americans formed their own segregated secret societies, benevolent organizations, and labor unions. According to *We Are a Part . . .* , meetings were held at the Good Samaritan Lodge Hall at 618 East McBee Avenue. Mutual aid societies and the working benevolent provided invaluable services for the sick and the bereaved. The general condition of African Americans was that of subservience to all whites. According to Mathis, this was a "relationship which was circumscribed by certain rigid rules of conduct understood and adhered to by African Americans, enforced and perpetuated by whites. To live within the frame work of those rules meant progress and prosperity. To defy those rules brought denouncement and retaliation. So it was that Greenville, a southern town was able to maintain its southern approach to all problems between African Americans and whites in the city, and yet maintain the appearance of complete and full freedom for all citizens." African Americans knew their place, and they stayed in it. During the 1920s, according to Stephen O'Neill, whites gained control over the two main leadership institutions in the black community. The once-independent Sterling Industrial Institute was incorporated into the school district, and the Phillis Wheatley Association by-laws were changed to require a majority of whites on the board. Social life in the African American community provided opportunities for fellowship, relaxation, and renewal before embarking on another week of work under often trying conditions. Social events also served as independent fund-raisers for worthwhile community causes, such as education. Greek-letter sororities and fraternities, Masonic orders, the Elks, and other social clubs have a long history of sponsoring annual cultural events and youth projects. The Alpha Kappa Alpha Sorority has introduced thousands of girls to society with the cotillion. Kappa Alpha Psi's Kappa Knights Program prepares black boys for life. The Elks Oratorical Contests prepare youth for leadership. Proceeds from these social events are used for college scholarships and to support youth activities in the community.

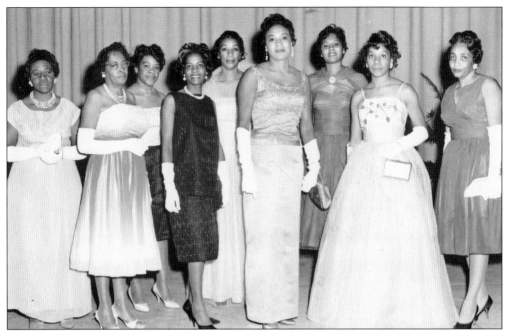

This photograph of members of Epsilon Iota Zeta Chapter of Zeta Phi Beta Sorority, Inc., was taken after a fund-raiser in 1956, the Blue Revue, a youth pageant. Proceeds from the Blue Revue support worthwhile community causes and provide college scholarships for youth. Epsilon Iota Zeta chapter was organized in Greenville in 1954. (Courtesy of the Robert Bradford Collection.)

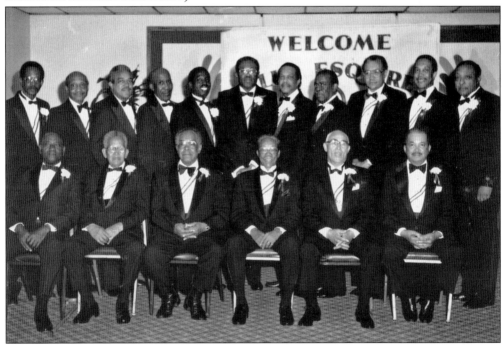

Club Esquire was organized in 1944. Members have a record of outstanding service to the community. (Courtesy of the Robert Bradford Collection.)

This photograph was taken at a formal that included many well-known teachers and their spouses. Such affairs provided a respite from the tedious task of educating pupils. (Courtesy of the Robert Bradford Collection.)

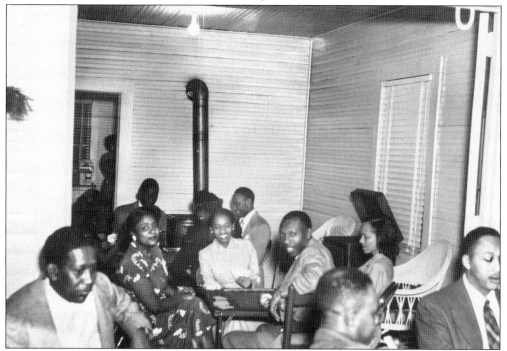

A get-together promoted lasting friendships and camaraderie. A pipe stove warmed many a card party in the 1940s. (Courtesy of the Robert Bradford Collection.)

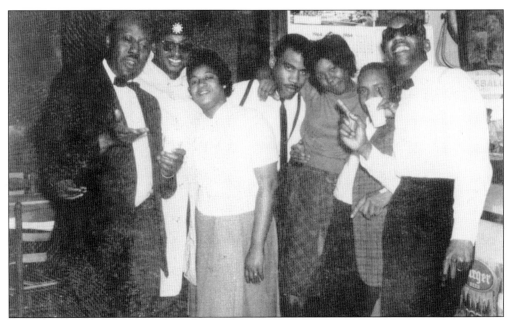

This image recalls the local Elks Club as the place to go to have a good time in the 1940s. (Courtesy of the Greenville Historical Society.)

Members of Webette's Temple No. 1312 of the Improved Benevolent Protective Order of the Elks of the World are shown here. The IBPOEW was founded in 1899. The purpose is "that the welfare and happiness of its members be promoted and enhanced, that nobleness of soul and goodness of the heart be cultivated, that the principles of Charity, Justice, Brotherly Love and Fidelity be inculcated, that its members and families be assisted and protected, and that the spirit of patriotism be enlivened and exalted." (Courtesy of Helen Isaac.)

The black church has historically promoted social activities in the black community. In this image, church members fellowship together at a holiday gathering at home. (Courtesy of the Robert Bradford Collection.)

The holiday season was also a special time for the black family. This is an image of members of the William Warren family at a Christmas social. (Courtesy of the Robert Bradford Collection.)

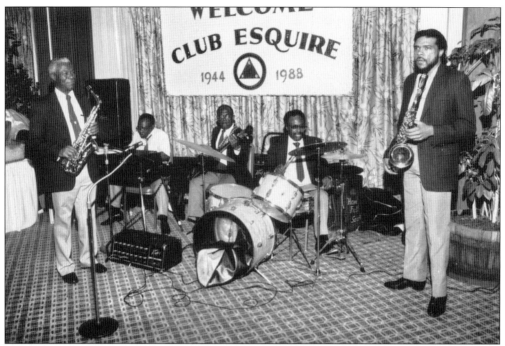

This photograph is a reminder of educator Bill Dover's (left) band and the role this band played in keeping the big band sound a part of the black experience in Greenville. (Courtesy of the Robert Bradford Collection.)

The black heritage with jazz at its best was guaranteed with Robert Moss Mack on horn (at right) and Eunice Parker of Night Breeze. (Courtesy of the Robert Bradford Collection.)

The holiday season afforded an opportunity for esteemed educators to socialize with each other. From left to right are Clemmie Jones, Rosa Newsome, Julius Kilgore, and Harold Newsome. (Courtesy of the Robert Bradford Collection.)

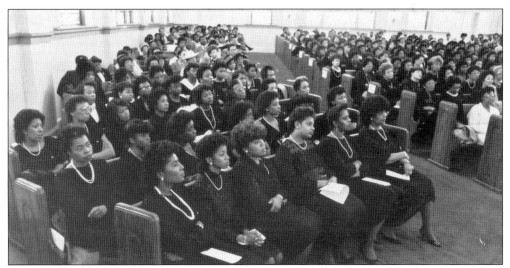

This photograph is a gathering of members of the Greenville Alumnae Chapter of Delta Sigma Theta Sorority at Allen Temple United Methodist Church. (Courtesy of the Robert Bradford Collection.)

Bishop Vashti Lyons McKenzie (second from left) poses with members of the Greenville Alumnae Chapter of Delta Sigma Theta Sorority. Years later, in July 2000, McKenzie, of Baltimore, Maryland, was appointed the first female bishop in the history of the African Methodist Episcopal Church. (Courtesy of the Robert Bradford Collection.)

Pictured above are members of the Greenville Alumnae Chapter of Delta Sigma Theta Sorority during the early 1980s following an event. The sorority supports several community agencies, programs for youth, and other worthy causes. (Courtesy of the Robert Bradford Collection.)

Seven

THE CIVIL RIGHTS MOVEMENT

When Jim Crow reared its ugly head in the early 1900s, there were a few brave African Americans who organized the Greenville NAACP in response to the Night Riders, cross burnings, and lynchings. The early leaders of the NAACP were Jim Brior, Pick Chappel, S. O. Walker, Ansel Arnold, Elrod Neeley, Alex Talbert, A. J. Whittenberg, Rev. O. S. Samples, H. W. D. Stewart, Rev. W. R. Martin, Isaac "Spears" Brockman, Geneva Young Blassingame, Bruce Barnes, Massalina Bowens, and Cliff Moore. Zora Hurst is also said to be an early leader in the NAACP. In 1947, the lynching of Willie Earle by a group of white cab drivers focused the attention of the world on Greenville. On New Year's Day, a massive march on the Greenville Municipal Airport protested the prejudiced treatment that baseball great Jackie Robinson experienced at the airport in October 1959. The march was sponsored by the NAACP, Congress of Racial Equality, and the Negro Ministerial Alliance. The protesters allowed inside the airport included Rev. James S. Hall, A. J. Wittenberg, attorney Donald James Sampson, attorney Matthew J. Perry, Rev. T. B. Thomas, Rev. S. E. Kay, Rev. Matthew D. McCollough, Rev. C. M. Johnson, R. H. Halle, Charlie Macon, H. P. Sharper, I. DeQuincey Newman, and John T. McCain. This protest was followed in 1960 by picket lines and sit-ins at downtown dime-store lunch counters, the library, the all-white Cleveland Park, and city buses. Arrests followed as violence erupted between the races on city streets, resulting in an evening curfew enforced by the city police department. As protests escalated, African Americans appeared before the Greenville City Council asking city leaders to provide leadership in repealing Jim Crow segregation laws. When no positive response was provided, student demonstrators decided to expand their Monday-through-Friday demonstrations to Sunday "pray-ins" at churches attended by the city's leaders. First Baptist Church and Buncombe Street United Methodist Church were the churches chosen. According to the City of Greenville's *175 Anniversary Timeline*, businessman Charles Daniel finally formed a biracial committee to address discrimination in Greenville. He said, "The segregation issue cannot continue to be hidden behind the door. This situation cannot be settled at the lunch counter and bus station levels. We must handle this ourselves, more realistically than heretofore; or it will be forced upon us in the harshest way. Either we act on our own terms or we forfeit the right to act."

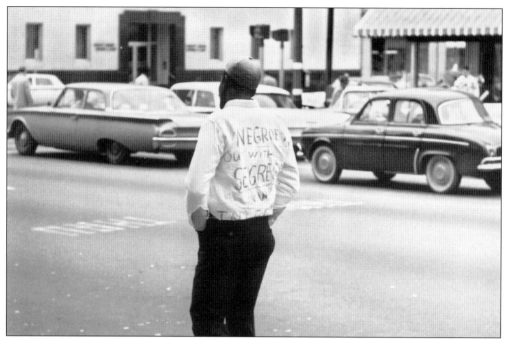

Picket lines in front of five-and-dime stores on Main Street became a common occurrence. This picketer wears the sign "Negroes: Out With Segregation." This was a bold message for anyone to wear during the days of Jim Crow. (Courtesy of the Upcountry History Museum, James Wilson Collection.)

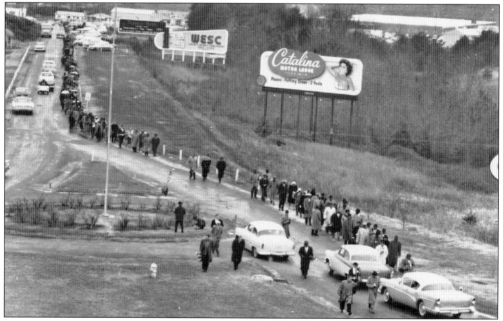

This is a scene from the historic march on the airport on New Year's Day 1960. The march included men, women, and children. All braved the elements and walked from Springfield Baptist Church to the downtown municipal airport and back. (Courtesy of the Upcountry History Museum, James Wilson Collection.)

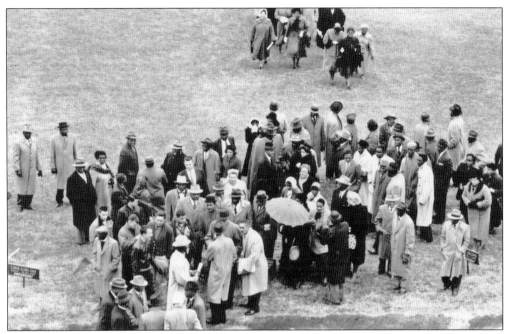

Protesters assemble on the airport grounds in 1959 in the struggle for racial equality in Greenville. Songs were sung, prayers were prayed, and statements were read. This march was a non-violent protest filled with dignity and respect. (Courtesy of the Upcountry History Museum, James Wilson Collection.)

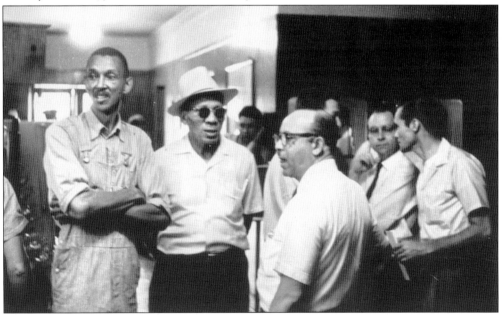

Mark Tolbert (at left), vice president of the Greenville branch of the NAACP, monitors the arrest scene. Tolbert was one of the top leaders in the state. His presence and level-headedness made the difference in the tenor of all demonstrations sanctioned by the Greenville branch of the NAACP. (Courtesy of the Upcountry History Museum, James Wilson Collection.)

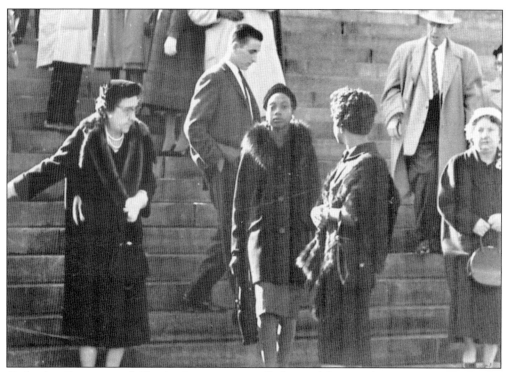

Catherine Duncan and Charity Jones were well dressed for Sunday service at First Baptist Church in January 1961. (Courtesy of the Upcountry History Museum, James Wilson Collection.)

Rev. James S. Hall was the charismatic leader of the 1960s protest movement in Greenville. He was the pastor of Springfield Baptist Church, home of the civil rights activities. (Courtesy of Leola Robinson-Simpson.)

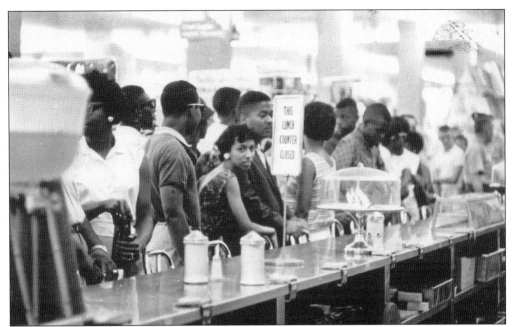

Student protests at lunch counters occurred after school and on Saturdays starting in March 1960. Demonstrators were directed to not laugh out or respond to hecklers, to look straight ahead at all times, read a menu, and look pleasant. Designated persons were asked to monitor the surroundings. (Courtesy of the Upcountry History Museum, James Wilson Collection.)

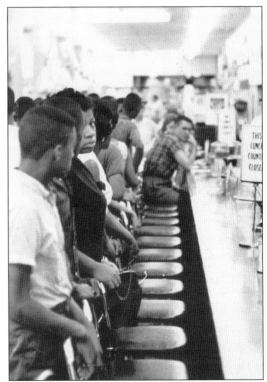

This is a typical scene from a lunch counter "stand-in." Protesters were instructed not to obstruct the operation of the store but to sit or stand quietly until dispersed. (Courtesy of the Upcountry History Museum, James Wilson Collection.)

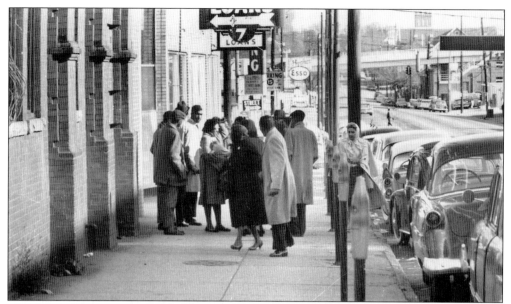

Members of the Greenville branch of the NAACP are pictured waiting on McBee Avenue outside the rear door at Kress for student protesters in case they are needed. Rev. James S. Hall, NAACP state vice president and pastor of Springfield Baptist Church, insisted on adults being close to the scene of the youth demonstrations. Fearless and faithful NAACP Youth Council advisors accompanying Reverend Hall were Peggy Parks, Cornelia Cato, and Juanita Carter. Carter was also the mother of three of the demonstrators, James ("Jimmy"), Raymond, and Charles. (Courtesy of the Upcountry History Museum, James Wilson Collection.)

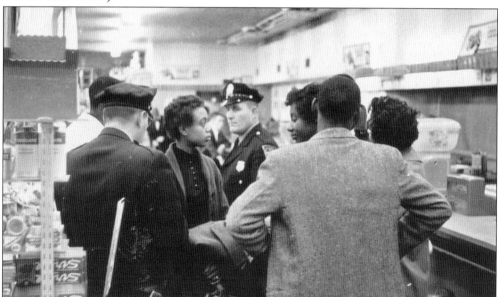

Pressure by dime-store managers to maintain order led to a strong police presence during demonstrations at lunch counters in the early 1960s. Students were orderly and quiet even when they refused orders to leave the store. (Courtesy of the Upcountry History Museum, James Wilson Collection.)

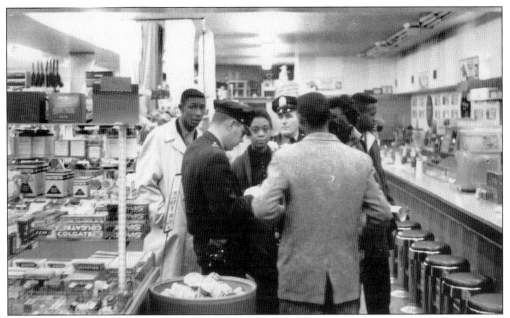

Protesters were instructed to not address waitresses unless the waitress asked the question, "May I help you?" Many students were approached by the police and threatened with arrest for disturbing the peace or trespassing. (Courtesy of the Upcountry History Museum, James Wilson Collection.)

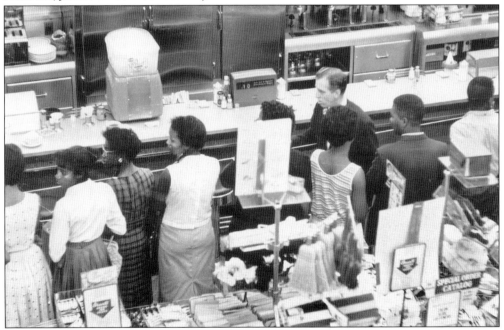

In this photograph, youth demonstrators are standing at the lunch counter. The numbers of demonstrators were often increased in order to impact the opportunity for white customers to be seated for service until after African Americans had been served. As a result, ropes were used to prevent students from being seated. (Courtesy of the Upcountry History Museum, James Wilson Collection.)

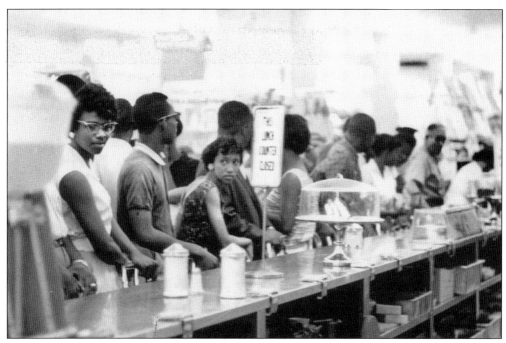

Demonstrations at lunch counters were called "sit-ins." Often they lasted from noon until 3:00 p.m., when the spokesperson would disperse the demonstrators. This was done to pressure the store managers to serve all customers with no regard to skin color. (Courtesy of the Upcountry History Museum, James Wilson Collection.)

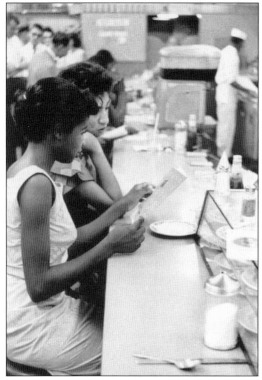

Sit-in demonstrators took time to read the menu. No whispering to other demonstrators, quiet comments, or giggling to one other was allowed. (Courtesy of the Upcountry History Museum, James Wilson Collection.)

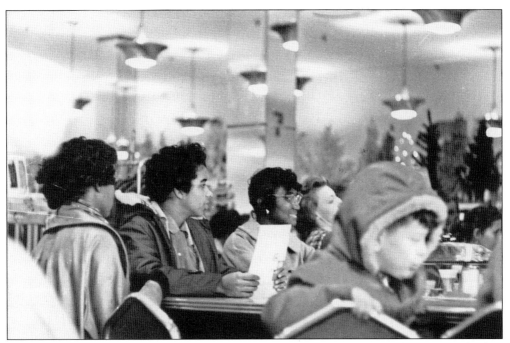

Sit-in demonstrators are seen pondering what to order in the event they were asked to place an order for service. Protesters were not permitted to force an order on a waitress. (Courtesy of the Upcountry History Museum, James Wilson Collection.)

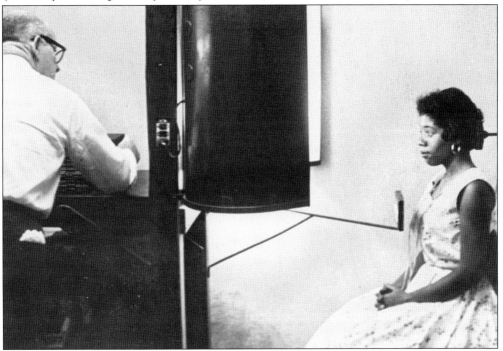

Dorris Wright, president of the Greenville Youth Council, gets photographed for her mug-shot after being arrested at the county library. (Courtesy of the Upcountry History Museum, James Wilson Collection.)

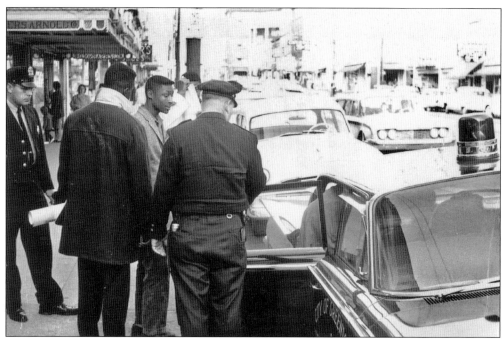

Sit-in demonstrators are led to police cars after being charged with disturbing the peace. Students were instructed to not resist being arrested but to remain peaceful and cooperative with local police officers at all times. (Courtesy of the Upcountry History Museum, James Wilson Collection.)

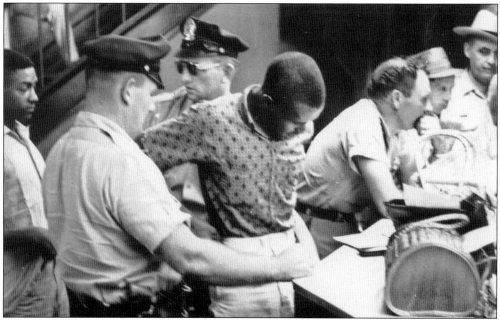

Sit-in demonstrators are handcuffed by the police. Handcuffing behind the back was very uncomfortable. However, students were warned to rotate shoulders periodically to ease the discomfort of being handcuffed and to remain pleasant in spite of the ordeal. (Courtesy of the Upcountry History Museum, James Wilson Collection.)

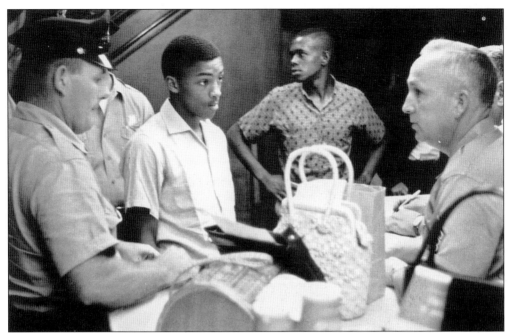

This is another image of the painful experience of being handcuffed by local police. The charges were trespassing or disturbing the peace. Students over the age of 15 were allowed bail of $30 to $40. Underage demonstrators were taken to the Negro Juvenile Facility on North Leach Street and held pending a hearing before a family court judge. (Courtesy of the Upcountry History Museum, James Wilson Collection.)

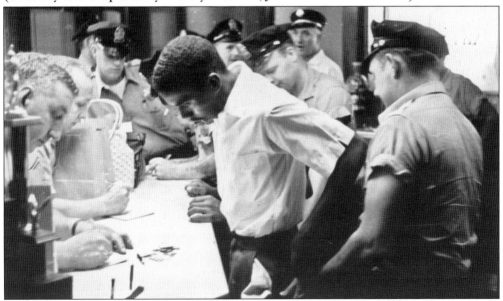

A sit-in demonstrator waits to be booked. This is an image of students being booked, which was a frequent occurrence. Students were fingerprinted, their mug shots were taken, and they were locked in the city jail at the corner of Broad and Falls Streets or at the old city stockade on Hudson Street. (Courtesy of the Upcountry History Museum, James Wilson Collection.)

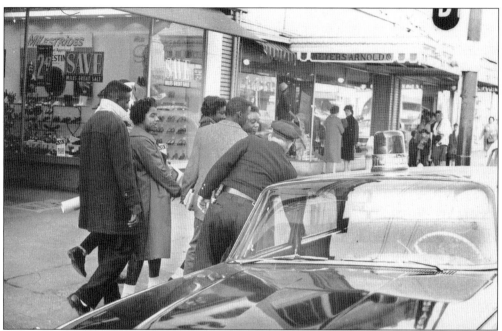

This image shows sit-in demonstrators being led to police cars. Students were sometimes quickly released after black bail bondsman Leroy "Tony" Shelton posted bail. Landowner Mark Tolbert, NAACP vice president, often used his property as collateral for bail for arrested students. (Courtesy of the Upcountry History Museum, James Wilson Collection.)

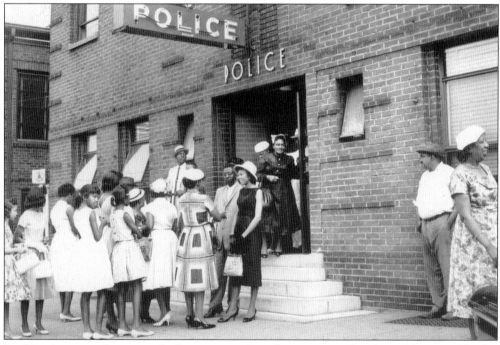

In this photograph, a crowd of parents and students are anxiously waiting outside the city police department on Broad Street for the release of relatives and friends. (Courtesy of the Upcountry History Museum, James Wilson Collection.)

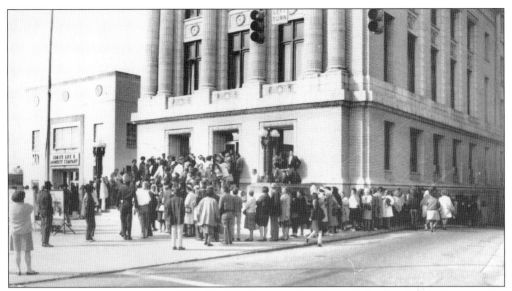

This image captures the support of the African American community for the demonstrators. On the day of the hearing for the youth charged as juveniles, the community gathered in large numbers outside Family Court Building on Main Street. Parents of juvenile protesters were severely rebuked by the judge and threatened if the juveniles participated in demonstrations in the future. (Courtesy of the Upcountry History Museum, James Wilson Collection.)

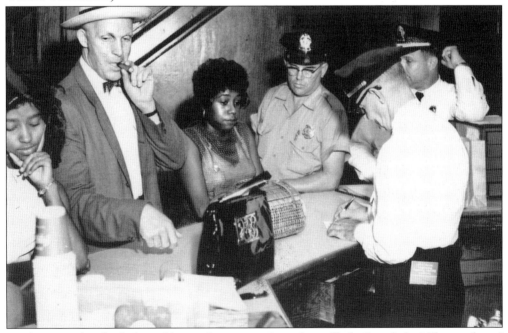

Students are booked after a library demonstration, also called a "study-in." The students' appearance and conduct exemplifies the manner in which the demonstrating youths conducted themselves. The students were released on a $30 bond provided by Leroy Shelton, attorney Donald James Sampson, and Mrs. E. L. McPherson. (Courtesy of the Upcountry History Museum, James Wilson Collection.)

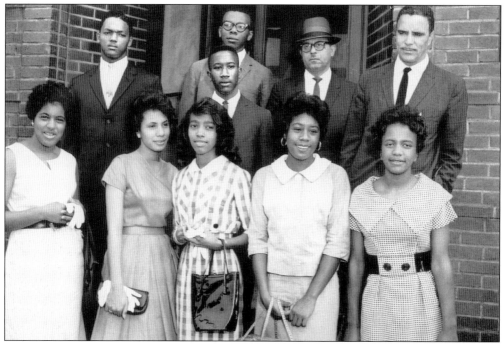

This is a photograph of the second arrest at the Greenville County Library on July 16, 1960, which involved college students and one high school student. The first library demonstration involved high school students on March 1, 1960, with first arrest on March 16, 1960. (Courtesy of the Upcountry History Museum, James Wilson Collection.)

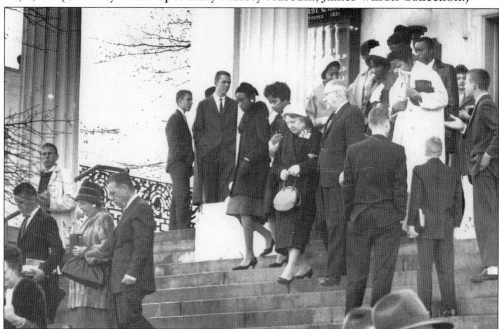

High school students leave a "pray-in" at First Baptist Church after finally being admitted for worship after being turned away on past occasions. (Courtesy of the Upcountry History Museum, James Wilson Collection.)

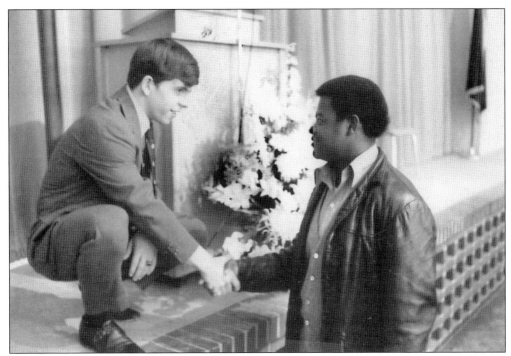

Students shake hands after an assembly at Wade Hampton High School in the days following school fights in November 1970 at several high schools. (Courtesy of the Upcountry History Museum, James Wilson Collection.)

This nostalgic image of Main Street at Christmas depicts Greenville during the time of the 1960–1961 sit-in demonstrations. This scene was often disturbed by picket lines in front of the five-and-dime stores Kress, Woolworth's, and Walgreens. Violence erupted between the races between July 21 and 25, 1960, and the city council imposed a 9:00 p.m. curfew on youth under the age of 19 on the streets of Greenville. The curfew was established to deter fighting between the races. (Courtesy of the Upcountry History Museum, James Wilson Collection.)

This photograph of shoppers crossing Main Street retraces the path demonstrators took to reach Woolworth's five-and-dime. It also shows the path troublemakers may have taken to attack the demonstrators on July 21, 1960, on Main Street. These attacks spread to other parts of the city, prompting the city council curfew. (Courtesy of the Upcountry History Museum, James Wilson Collection.)

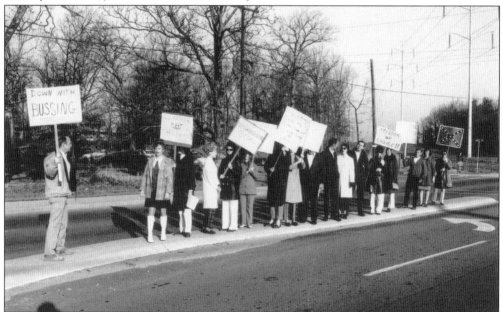

White demonstrators picket with signs that read, "Down with bussing," capturing the mood of the white community, in the wake of school desegregation. Some white parents were afraid their children would be bussed to black schools. They were also upset at the prospect of black students attending formerly white schools. (Courtesy of the Upcountry History Museum, James Wilson Collection.)

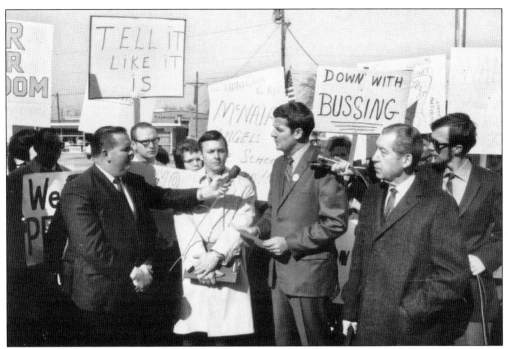

White protestors "tell it like it is" regarding the bussing of students to comply with the federal court order. (Courtesy of the Upcountry History Museum, James Wilson Collection.)

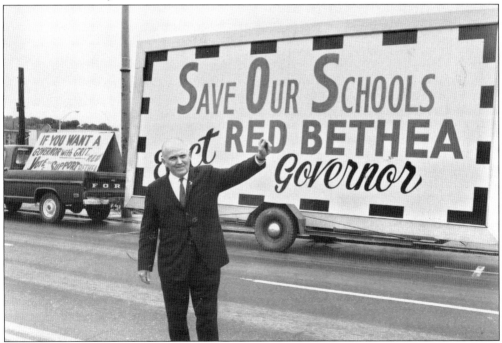

Save Our Schools became a campaign issue for white politicians. Political lines were clearly drawn, and candidates made platform promises surrounding the issue of bussing. (Courtesy of the Upcountry History Museum, James Wilson Collection.)

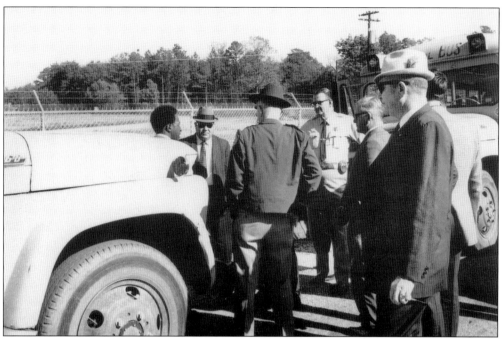

In this scene, whites are seen talking to a black bus driver. Hundreds of black students were given police escorts after fights at several high schools in November 1970. State highway patrolmen assisted, with the National Guard on standing alert. (Courtesy of the Upcountry History Museum, James Wilson Collection.)

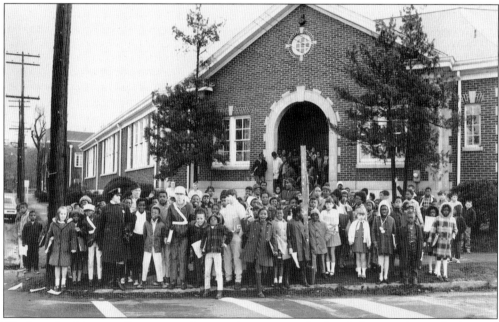

Black and white pupils emerge from a desegregated school during the early days of desegregation in 1970. During the early integration days, black children were reportedly pacified with coloring assignments while white children were taught in some classes. (Courtesy of the Upcountry History Museum, James Wilson Collection.)

Eight

SOME OF THE WAY MAKERS

Nearly 100 contacts were made to identify and obtain images of way makers in Greenville. Many of the photographs submitted could not be used because the quality of the images was too poor. Many way makers were unable to respond due to time constraints and space. However, countless numbers of people in the Greenville community have paved the way with African American businesses, services, and their unique leadership.

According to *We Are a Part . . .* , many African Americans from Greenville have achieved in the arts and athletics. Rhoda Boggs became a celebrated concert vocalist in the 1940s. Marie Barnes, a talented mezzo-soprano, joined the Anota Opera Company in 1963. Sarah Reece became a distinguished soloist with various opera companies during the 1980s. Josh Daniel White became a virtuoso on the guitar and tambourine, singing the blues at the White House during the administration of Franklin D. Roosevelt. Peggy Dillard, a top model, made the cover of leading magazines in the 1970s and 1980s. John Pendarvis, a mixed-media artist, has exhibited his works in New York and throughout the South.

In sports, the Greenville Spinners baseball team had players such as M. C. Clark, John Austin, and Mark Durham, who fired up fans of the Southern African American Baseball League. Games were played at Meadowbrook Park from 1923 to 1962. Charles Jackson, John Jones, Claude Smith, and James Edgar "Tiny" Smith were outstanding players. By the mid-1950s and 1960s, high schools were the training ground for athletes. Joseph Mathis, Jiles Edwards, Alphonso Allen, Nathaniel Hartman, Eddie Jones, Al Duckett, and Louie Golden coached at Sterling, Lincoln, Bryson, Washington, and Beck High Schools. These schools gained state-wide recognition and sent several local players to the NFL: Arthur Jones, J. D. Smith, R. C. Gambrell, William Thompson, Lawrence Acker, Perry Smith, Roy Kirksey, William Belton, and Dextor Clinkscales. Greenvillians playing professional basketball include Ernest Brock and Clyde Mayes Jr. Rico Dawson played professional baseball. In 1966, Richard Charles Kerns ran the 100-yard dash in 9.2 seconds, surpassing Olympic great Jesse Owens's record.

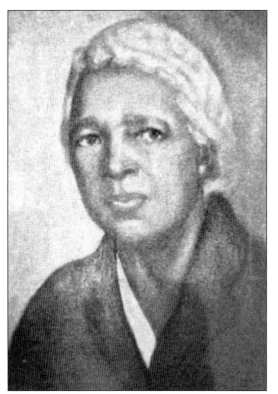

Hattie Logan Duckett was one of the greatest women in Greenville's history. A proud and dedicated black woman and a visionary teacher, Duckett saw the neglect of black girls and boys in Greenville. She took the initiative to gather children off the streets to involve them in wholesome after-school and weekend activities, often with her own funds. She is the founder of the Phillis Wheatley Center, a vehicle for the growth and development of the community until the present day. (Courtesy of the Phillis Wheatley Association.)

Edgar "Tiny" Smith commanded the Phillis Wheatley Center from 1948 to 1967 after the retirement of Hattie Logan Duckett. Under his leadership, blacks were prepared for emerging jobs in Greenville during the early 1960s. (Courtesy of the Phillis Wheatley Association.)

Bobbie Clinkscales, Phillis Wheatley's bookkeeper, stood in the gap between directors by serving as interim director in 1967 and in 1970. A strong and knowledgeable woman, Clinkscales smoothed the transition in leadership using her wisdom and experience. (Courtesy of the Phillis Wheatley Association.)

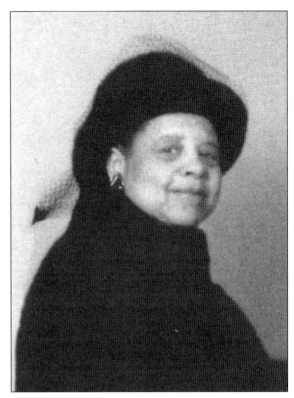

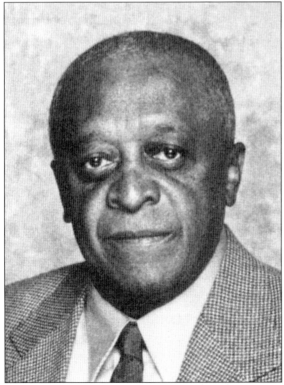

Alphonso W. Allen was executive director of the Phillis Wheatley Center from 1968 to 1970, the year that public schools were ordered by the court to integrate. He provided activities to assist in the transition from segregation to integration. (Courtesy of the Phillis Wheatley Association.)

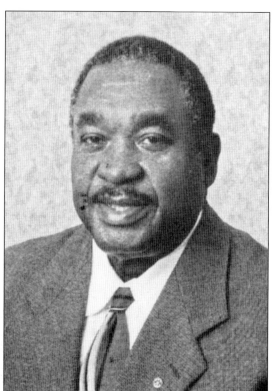

John McCarroll led the Phillis Wheatley Center from 1970 to 2001, bringing in new programs, such as Big Brothers Big Sisters of America. (Courtesy of the Phillis Wheatley Association.)

The Phillis Wheatley Center moved from Broad Street to a new facility at 335 Greenacre Road in June 1977. In 1994, a capital campaign was initiated and a second building was constructed at the site, which opened in September 1999. With John McCarroll's retirement, William Ross served as executive director from 2001 to 2003, followed by Dayatra C. Baker-White, who served in 2003, followed by Eric Carpenter in 2004. (Courtesy of the Phillis Wheatley Association.)

Dwight Woods has touched the lives of hundreds of Greenville youth through the spectacular Repertory Theater for Youth (RTY) at the Phillis Wheatley Center. Founded in the summer of 1985, Woods's group of talented singers, dancers, orators, and musicians has been recognized by the President's Committee on the Arts and the Humanities and the National Endowment for the Arts and the Humanities. RTY members have been steered from high school into colleges and universities. (Courtesy of the Phillis Wheatley Association.)

Sen. Ralph Anderson is a career public servant. He retired as postmaster after 30 years of service. He then served on the Greenville City Council from 1983 to 1991, where he pushed for the construction of affordable housing and tutorial programs with city funds. Anderson served in the South Carolina House of Representatives from 1991 to 1996, where he worked to increase funding for public education and to increase assistance for senior citizens. Senator Anderson has served in the senate, representing District 7 since 1996. Known as the "People's Senator," Senator Anderson has annually received "A" ratings for his advocacy for education for his work with offenders and their families. (Courtesy of Ralph Anderson.)

Dr. Willis Crosby Jr. is the president and chief executive officer of Sunbelt Human Advancement Resources (SHARE), a community action partnership chartered in 1965. Dr. Crosby guides a staff of some 300 employees in the administration of 34 self-sufficiency programs and services, including Head Start in Greenville, Anderson, Pickens, and Oconee Counties. Under his leadership over more than three decades, SHARE has won numerous awards for excellence. (Courtesy of Dr. Willis Crosby.)

Ruth Ann Butler has dedicated her life to preserving black history and culture. She is the founder and executive director of the Greenville Cultural Exchange Center, a cultural center and repository for black history dating back to the late 1900s. She is a graduate of Sterling High School and a former public school teacher. She is a consultant for the Bell South African American Calendar for South Carolina, and she was a consultant for the SCETV documentary movie on the life of "Peg Leg" Bates. She is the author of the book *Sterling High School, Bless Her Name*. (Courtesy of Ruth Ann Butler.)

The Cultural Exchange Center is a resource center and museum that showcases the historical achievements of African Americans in the Greenville area. The center is located at the corner of Sumner Street and Arlington Avenue in the historic West End neighborhood near downtown Greenville. The newly renovated building features an extensive catalogue of artifacts, local histories, and genealogy records. It is a preferred meeting place for local groups. (Courtesy of Ruth Ann Butler.)

Peg Leg Bates lost his leg in a cotton gin accident at the age of 12 and taught himself to dance on a crude wooden leg. He danced on the streets and in the barbershops of Fountain Inn for pocket change. He performed in the musical *Blackbirds* with Mantan Moreland, Moms Mabley, and Bill Robinson, known as Mr. Bojangles. His tap-dancing career spanned more than 71 years. He traveled around the world three times, was a regular performer on the Ed Sullivan Show, and gave two command performances before the king and queen of England. He has been honored internationally. (Courtesy of Wanza Bates.)

Melvin Davis was a strong advocate for black business economic development, voter registration, and political involvement. He and his wife, Dawn Franks Davis, opened the new building for the historic S. C. Franks Chapel of Remembrance on Augusta Street after operating for decades at the old mortuary building on Anderson Street. As a young businessman, Davis co-owned the Bow Tie Lounge on Broad Street and later the Bow Tie Grand on South Pleasantburg Drive. A popular youth motivational speaker, Melvin Davis set the tone for young people to "Do something. Be something." (Courtesy of Dawn Franks Davis.)

Jimmie Wilson was appointed the first black magistrate of Greenville County in April 1978. He retired in 1990. A manager for Clark's Funeral Home for 55 years, he served as state director of education and as and state secretary for the Elks State Association in addition to service in the church and community. (Courtesy of Dr. Ann Pinson.)

Willie L. Johnson is the first black chief of police for the city of Greenville. He is a career police officer who climbed the ranks to the position of captain and then chief of police. He leads a corps of officers and staff in the Greenville Police Department Professional Standards and Services Division, Patrol Services Division, Investigative Services Division, and Support Services Division. Under his leadership, crime rates have been reduced and the quality of life has improved in the city of Greenville. (Courtesy of Willie Johnson.)

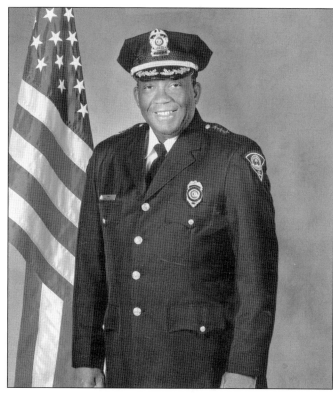

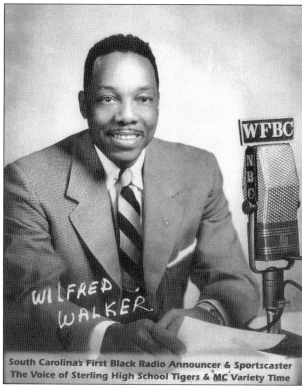

South Carolina's First Black Radio Announcer & Sportscaster
The Voice of Sterling High School Tigers & MC Variety Time

Wilfred J. Walker was an educator at Sterling High School who in 1948 broke the color line when he began broadcasting football games from Sirrine Stadium. The simulcast (PA system and radio) became a big hit. Walker was employed to do an afternoon radio show he called *Tip Time* in 1952, moving from Mayberry Park to the WMRC studios in the Provost Building on Main Street. When WMRC merged with WFBC, Walker moved to the new WFBC Building on Rutherford Street working side by side with the white announcers and staff. Walker changed the name of the show to *Variety Time* to accommodate the variety of listeners. Walker remains a mentor to former students and other youth today. (Courtesy of Wilfred J. Walker.)

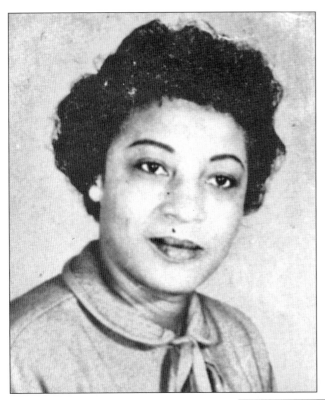

In 1953, educator Marie Y. Bates became the first black woman to host a radio show, covering subjects of community interest. Dedicated to improving opportunities for women and girls, in 1954, Bates was a charter member of Epsilon Iota Zeta Chapter of Zeta Phi Beta Sorority, Inc., and in 1979, Marie Bates also organized a Greenville section of the National Council of Negro Women. (Courtesy of Leola Robinson-Simpson.)

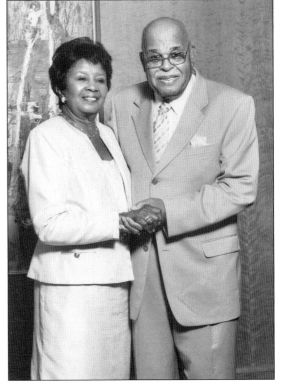

Fred Garrett is pictured with his wife, educator Mamie Garrett. He willingly shares over a half century of lifetime of experience in business and human relations. Fred came to Greenville in 1952 as a county farm-extension agent, assisting rural farmers and their families. He spent the next 44 years as a funeral director, assisting families in their time of loss. His compassion as leader of the Watkins, Garrett, and Woods Mortuary also drives his service in the community and in the church. (Courtesy of Fred D. Garrett.)

Brandon Brown is a young black man who is making his mark on Greenville's history. He ran a thought-provoking and issues-oriented race for the U.S. House of Representatives for Congressional District 4 in 2004. Though unsuccessful in his bid, he has uplifted the black community in the Upstate with three major, highly successful community projects: the Greenville HBCU (Historically Black College and University) Annual Basketball Classic and College Fair, the annual Greenville HBCU Football Classic and College Fair, and the Black Family Reunion. Brandon Brown copioneered these events in conjunction with JAMZ 107.3 radio and Rev. Caesar Richburg, pastor of Allen Temple AME Church. (Courtesy of Brandon Brown.)

The support of local radio stations such as 107.3 JAMZ contributed to the massive turnout of support for the paid Dr. Martin Luther King Jr. holiday, the annual HCBU Football and Basketball Classics, and the annual Black Family Reunion. (Courtesy of WJMZ 107.3 JAMZ.)

James Floyd, former public school teacher and coach, engineer, businessman, and community servant, has the distinction of serving as the past national president of Phi Beta Sigma Fraternity. He was listed for three years in Ebony Magazine's 100 Most Influential Blacks in America. Owner, president, and chief executive officer of F&M Development, Inc., James T. Floyd Construction, and Unlimited General Construction, he is providing opportunities for black involvement in the construction market in the state of South Carolina. (Courtesy of James Floyd.)

James and Joyce Bobo worked as a team for several community weekly newspapers. In 1996, they decided to start a black weekly newspaper, the *Community Informer*. This newspaper was started in a former coal house in their backyard. The used all the funds they had to purchase a computer, office equipment, and supplies, and the rest is history. The *Community Informer* is a lifeline for blacks in the Upstate. (Courtesy of James Bobo.)

Dr. Willie Frank "Bill" Gibson, a Greenville dentist, became a drum major for justice. He chaired the first voter-education project in Greenville. His successful fight for single-member districts facilitated the election of blacks to local- and state-elected offices. He founded the Black Council for Progress in Greenville to negotiate fair share agreements with local government and businesses. His election to local and state NAACP leadership led to his service as chairman of the NAACP National Board of Directors from 1985 to 1996. At the helm of the largest and most respected civil rights organization, Gibson was highly successful in leveraging economic opportunities nationwide. (Courtesy of Lottie Gibson.)

Lottie Beal Gibson, educator and civil rights activist, has been a champion for the poor for over 50 years. She directed student support programs at Greenville Technical College for over 30 years. Elected to the county council in 1992, Lottie Beal Gibson never gave up on making Dr. Martin Luther King Jr.'s birthday a holiday for county employees. A local Jefferson Award winner, Gibson has been an advocate for the poor in the Greenville area through her leadership on the board of SHARE and numerous other organizations. (Courtesy of Lottie Gibson.)

Educator Horace Nash was called a civil rights legend and pioneer in Greenville. His NAACP leadership spanned over four decades. He was president of the Greenville Youth Council of the NAACP as a teenager in 1961, participated in sit-ins, and led the Greenville branch of the NAACP from 2001 to 2003 as an adult. He took pride in managing the successful campaigns of many black elected officials. He was the general manager of annual voter registration efforts, and he joined the fight for a Greenville County holiday honoring Dr. Martin Luther King Jr. (Courtesy of Leola Robinson-Simpson.)

Theo Mitchell represented District 7 in the state senate after serving five terms in the South Carolina House of Representatives. He served as vice chairman of the Greenville County Legislative Delegation in 1984 and served as chairman from 1986 to 1989. He formerly chaired the South Carolina Legislative Black Caucus and, in June 1990, won the Democratic Party nomination for governor of South Carolina with opposition. He was defeated in his bid for governor by the incumbent. (Courtesy of Theo Walker Mitchell.)

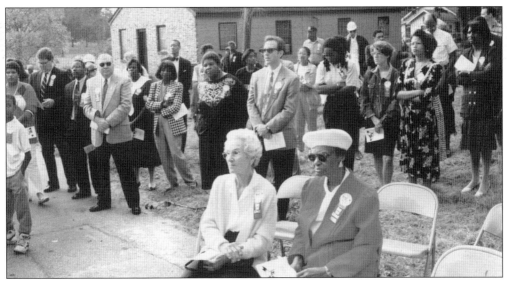

Lila Mae Brock was a great community organizer. City officials left city hall at her invitation to a community gathering. She opened the Southernside Center in February 1982. She dedicated her life to helping the less fortunate in Greenville with food, clothing, and shelter. With donations from churches and her own Social Security check, Brock was able to keep the doors of the Southernside Center open. A grant from the U.S. Department of Housing and Urban Development led to the construction of 68 units to house the elderly and the handicapped. These units were appropriately named Brockwood Apartments in her honor. (Courtesy of the City of Greenville Community Development Department.)

Lillian Brock-Flemming was a first in many areas. She was one of the first African American students to attend and graduate from Furman University. She was the first African American woman to be elected to city council. She was the longtime mayor pro tem of the Greenville City Council, proudly representing the city whenever required. She was elected president of the Municipal Association of South Carolina in July 2003, becoming the first council member and the first woman from the city of Greenville to be so honored in the 64-year history of the organization. She was elected to the board of the Municipal Association in 1997 and has served as third, second, and first vice president and chair of the legislative committee. The Municipal Association is a voice for the needs and concerns of municipalities in South Carolina. (Courtesy of the City of Greenville.)

Willie T. Smith Jr., family court judge, was a trailblazer. He was one of two black lawyers who led the fight in the courts to integrate the public schools, lunch counters, libraries, hotels, and buses in Greenville. He served as executive director of Greenville County Legal Services, a group that helped people who could not afford legal counsel. He also served on the bench of the Greenville Family Court assisting families. (Courtesy of Anna Marie Smith.)

Robert E. Jenkins served as director and chief attorney for Legal Services Agency of Western Carolina, Inc., from 1979 to 1996 providing legal assistance to the poor. He pioneered a program called Libra Society, which enabled private lawyers to give pro bono legal services to poor people who could not be helped by Legal Services. In 1996, he was elected by the South Carolina General Assembly to serve as judge of the Circuit Family Court of the 13th Judicial Circuit, seat number five. (Courtesy of Robert E. Jenkins.)

Merl F. Code was appointed Greenville's first African American municipal court judge. His sound thinking makes him a powerful presence in the courtroom and in the boardroom of an array of colleges and universities, banking, civic, and business groups. His memberships and board affiliations are substantial, including serving as chairman of the board of directors for the Greenville Chamber of Commerce. A businessman, he is the owner and chief executive officer of Precision Tool Manufacturer and owner/chairman of Code Insurance Associates. He is also an attorney with Ogletree, Deakins, Nash, Smoak and Stewart, P.C. A popular motivational speaker, he is included annually among the "Most Influential Greenvillians" for good reason. (Courtesy of Merl F. Code.)

Marion Beasley, owner of Beasley Funeral Home, has provided many years of faithful leadership in his service on the South Carolina Board of Parole, Probation, and Pardon Services. Trips to parole hearings in Columbia became a part of his routine scheduling. Giving each inmate a fair opportunity to be considered for release from prison is too serious to be taken lightly. Marion Beasley is a humanitarian, a community servant, and a pillar of the community in Fountain Inn. (Courtesy of Marion Beasley.)

Efia Nwangaza, attorney at law, is a voice for the voiceless. She is a fearless defender of justice and is dedicated to the liberation of black people. She is the founder of the Malcolm X Grassroots Movement and the Malcolm X Bookstore and Reading Room. In this image, Efia Nwangaza, Green Party candidate for the U.S. Senate, stands on the 40th anniversary of the 1965 Voting Rights Act and in memoriam to Septima Clark, Majeska Simpkins, and Fannie Lou Hamer. (Courtesy of Efia Nwangaza.)

Bishop Johnnie Smith is the first black ever to be elected to a state GOP office. In 1989, Smith, a county councilman, was elected second vice chair of the state Republican Party. A member of the Commission on National and Community Service, Smith had the ear of Presidents Ronald Reagan, George Bush, George W. Bush, and Gerald Ford on matters of community interest. In 1997, Bishop Smith was awarded the Order of the Palmetto, the highest award that can be given to a civilian in South Carolina. (Courtesy of Bishop Johnnie Smith.)

Dr. Levi Kirkland opened an office for the practice of medicine in 1961 in a building at the corner of Green Avenue and Ansel Street in the historic West End. Dr. Kirkland spent the next 44 years diagnosing illnesses and treating the ailments of patients, many of whom were the poor and needy. Often his office was a free medical clinic because he was committed to his work. (Courtesy of Dr. Levi Kirkland.)

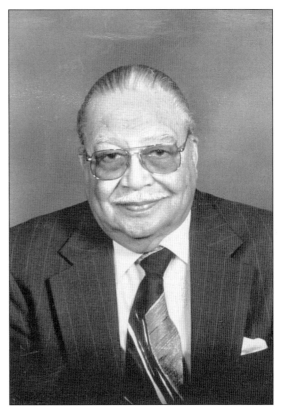

Dorothy Brockman is a leader in the Greenville community. Brockman has worked in city recreation services for the City of Greenville for over 50 years. She organized the annual Miss Parks and Recreation Pageant for youth and adults for cultural enrichment. (Courtesy of the City of Greenville Community Development Department.)

Leola Clement Robinson-Simpson was arrested for the first time in Greenville at the age of 15 and was confined with other demonstrators at the local black juvenile facility. She served as state president of youth councils and college chapters of the NAACP from 1960 to 1962. She was elected to the Greenville County School Board in 1996. In June 2000, she founded the Center for Educational Equity (CEE), a non-profit group that sponsors a Saturday Success School for low-income students and parent-empowerment classes for parents. (Courtesy of Joe Long.)

Xanthene Sayles Norris, respected educator and county council member, led the fight for a paid holiday for Dr. Martin Luther King Jr.'s birthday. Norris is a longtime community servant and role model. She is known for her work with the Urban League's Talent Search Program and the UNCF of the Upstate's fund-raisers.

Nine

THE STRUGGLE
CONTINUES

Over 40 years after the march on the municipal airport in 1959, marching days were not over in Greenville. The struggle continued. On May 17, 2003, Greenville native Rev. Jesse Jackson, former U.S. presidential candidate and the head of the National Rainbow-PUSH Coalition, joined county councilwomen Lottie Beal Gibson and Xanthene Norris in urging the Greenville County Council to join the rest of the nation, after 26 years of refusals, in declaring Dr. Martin Luther King Jr.'s birthday a paid holiday in Greenville. Under the leadership of Reverend Jackson and a coalition that involved the Rainbow-PUSH, the NAACP, and the ministerial community, a march for justice was held. More than 30,000 people marched across the Church Street Bridge in Greenville to the offices of the Greenville County Council in protest. The following year, another massive march down Main Street was held. By the next election, enough opponents of the Martin Luther King Jr. holiday were unseated to produce a majority of council members in favor of the holiday. The struggle also continues for social justice and educational equity.

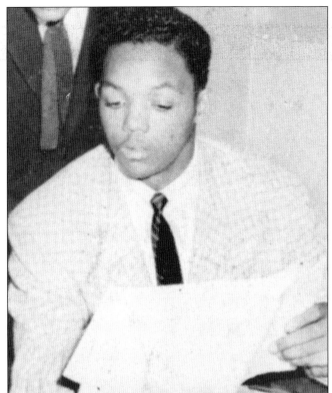

This is an archive photograph of Rev. Jesse Jackson when he was a young student at Sterling High School in 1958. A Greenville native, the Reverend Jesse Jackson continues to be a catalyst for social and economic justice. A former candidate for president of the United States and a global peacemaker, Reverend Jackson has never forgotten his roots in Greenville. It was only when Reverend Jackson took the helm in the struggle with Greenville County Council to have Dr. Martin Luther King Jr.'s birthday declared a paid national holiday for county employees that a change occurred. (Courtesy of the Greenville Cultural Exchange Center.)

This is a photograph of a sit-in at the Greenville County Council led by Rev. Jesse Jackson and a passive outpouring of community leaders in support of a paid holiday for the celebration of Dr. Martin Luther King Jr.'s birthday.

This is a scene from one of the many protests surrounding the county's refusal to follow the rest of the nation in declaring the birthday of Dr. Martin Luther King Jr. a paid holiday. In this photograph, 30,000 people march on May 17, 2003, down Church Street to County Square on University Ridge.

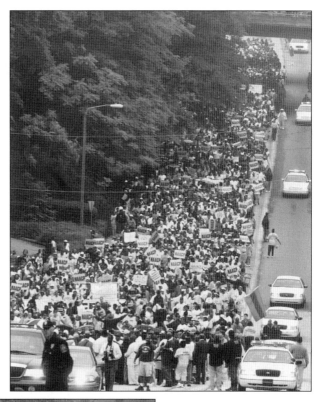

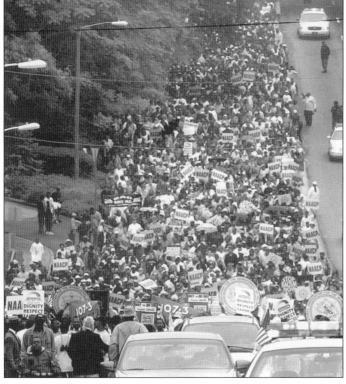

This is another image that captures the scene at a Martin Luther King Jr. demonstration at county council led by Rev. Jesse Jackson. The crowd of protesters was upbeat and optimistic. Protesters were orderly and remained outside once the council chambers were filled. (Courtesy Owen Riley, *Greenville News*.)

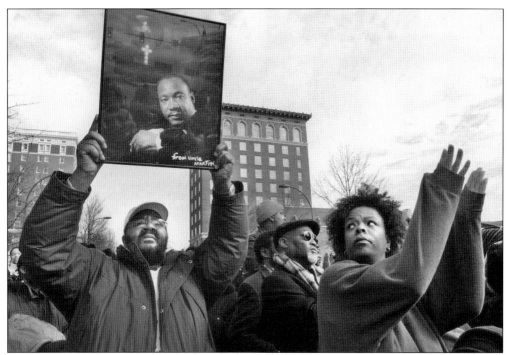

During this upbeat rally for a paid Martin Luther King Jr. holiday in Greenville, Willie Tutt of Greenville holds his Martin Luther King poster up high as Antoinette Hicks looks up. (Courtesy Owen Riley, *Greenville News*.)

Minister William Muhammad of the Nation of Islam (left), attorney Efia Nwangaza (center), and Rev. Jesse Jackson take time for children. (Courtesy Owen Riley, *Greenville News*.)

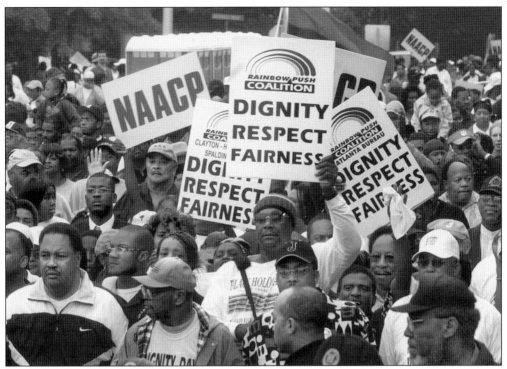

This photograph shows protesters at the Martin Luther King Jr. March with a variety of signs. (Courtesy Owen Riley, *Greenville News*.)

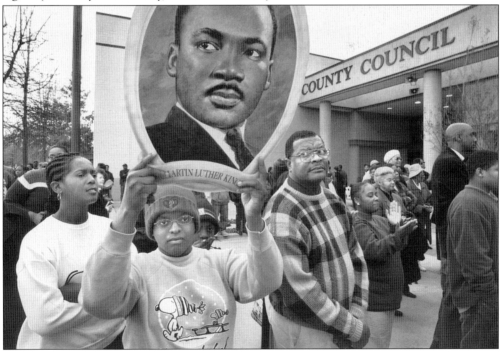

Many protesters stood outside county council chambers for hours in support of a paid Martin Luther King Jr. holiday. (Courtesy Owen Riley, *Greenville News*.)

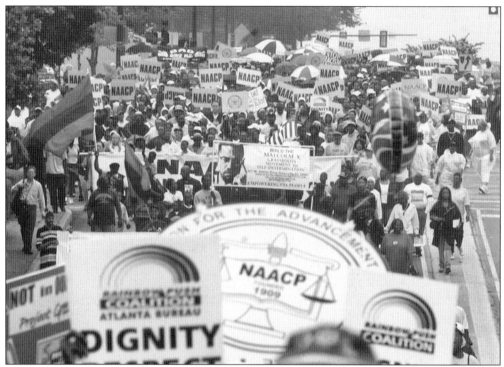

Marchers press on down Church Street holding signs and singing. (Courtesy Owen Riley, *Greenville News*.)

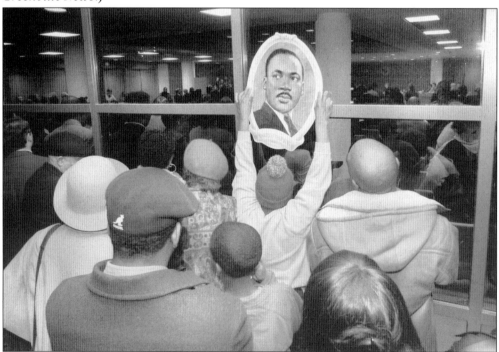

This is another image from the Martin Luther King Jr. holiday protests. (Courtesy Owen Riley, *Greenville News*.)

Youth who visited the Lorraine Hotel and the National Civil Rights Museum in Memphis participated in the marches for a paid holiday for Dr. Martin Luther King Jr. (Courtesy Shakir Robinson, Success Athletics.)

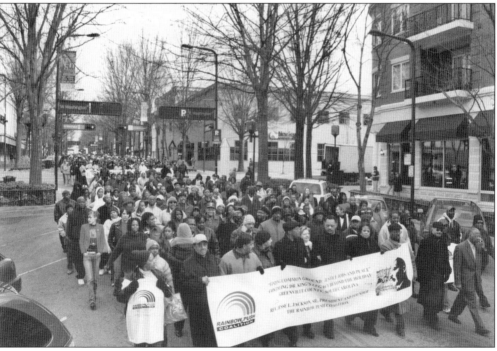

This image shows Rainbow-PUSH marchers on Main Street in downtown Greenville in 2004. (Courtesy of Dr. Aminah Richburg.)

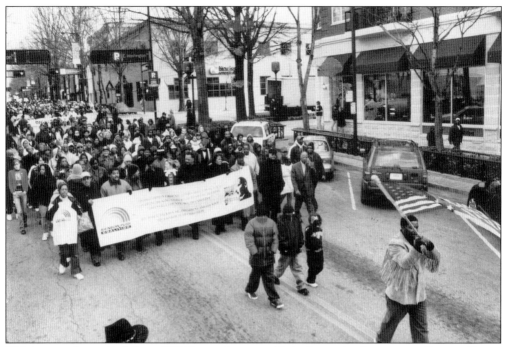

This image shows Rainbow-PUSH marchers on Main Street in downtown Greenville on January 15, 2005. (Courtesy of Dr. Aminah Richburg.)

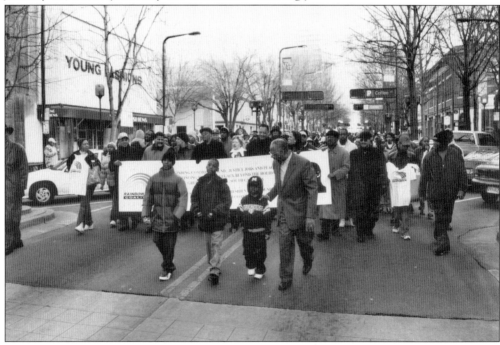

This image shows Rainbow-PUSH marchers on Main Street in downtown Greenville on January 15, 2005. Children, led by Rev. Caesar Richburg, local PUSH president and pastor of Allen Temple AME Church, are near the front of the march. (Courtesy of Dr. Aminah Richburg.)

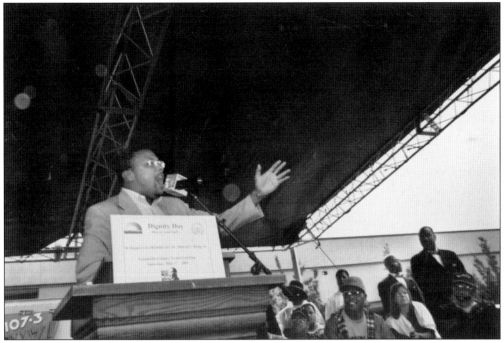

This photograph shows Judge Mathis at the podium at the Martin Luther King Jr. rally on May 17, 2003. (Courtesy of Leola Robinson-Simpson.)

Center for Education Equity students participate in the May 17, 2004, Martin Luther King Jr. March. (Courtesy of Leola Robinson-Simpson.)

The struggle continues in education. This photograph shows Minister William Muhammad of the Nation of Islam speaking to a parent group on the needs of children, as taught by the Honorable Elijah Muhammad and the Honorable Louis Farrakhan. (Courtesy of Joe Long.)

The struggle continues in parent awareness and participation in school activities. Attorney Kimaka Nichols-Graham of the South Carolina Centers for Equal Justice conducts weekly workshops for parent groups to promote parent involvement in the school system. (Courtesy of Joe Long.)

The struggle continues in advocacy to close the gaps in achievement. Rev. J. M. Flemming of Concerned Citizens for Equal Justice speaks out on the needs of black students and the closing of black schools. (Courtesy of Joe Long.)

The struggle continues with the need for black parents to attend local school board meetings. Retired educator Winfred Daniels speaks out at a school board meeting on the closing of black schools. (Courtesy of Leola Robinson-Simpson.)

The struggle continues in the need to sponsor more community programs to work with children who need additional assistance and motivation to succeed in school. In the above photograph, Dr. Aminah Richburg works to help prepare Saturday Success School students for the PACT. (Courtesy of Joe Long.)

Retired educator Fred Bostic works with youth and parents on Saturdays at the Saturday Success School in an effort to reduce school suspension rates and the dropout rate. (Courtesy of Joe Long.)

The struggle continues with the need for more young men to work with black boys in the community to promote discipline through athletics and academic achievement through special programs. Pictured in the second row fourth from left is Justin Griffith of the Atlanta Falcons NFL team, a guest speaker at a "Success" event. (Courtesy of Joe Long.)

Educator Reginald Williams works during the summer with the Success School youth. (Courtesy of Joe Long.)

Talented members of the highly acclaimed Phillis Wheatley Repertory Theater practice for a performance. Dwight Woods is the director. (Courtesy of the Phillis Wheatley Association.)

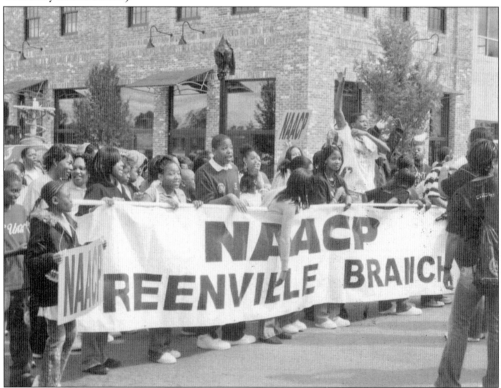

Behind the NAACP banner, members of the youth council march to promote positive attitudes and behavior among youth in school on October 7, 2006, renewing hope for the future. (Courtesy of WJMZ 107.3 JAMZ.)

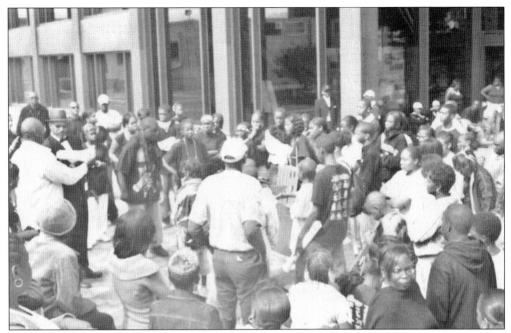

At a city hall press conference, the NAACP Youth Council affirms its support of the Impact Player Pledge, encouraging an end to school suspensions and violence. (Courtesy of WJMZ 107.3 JAMZ.)

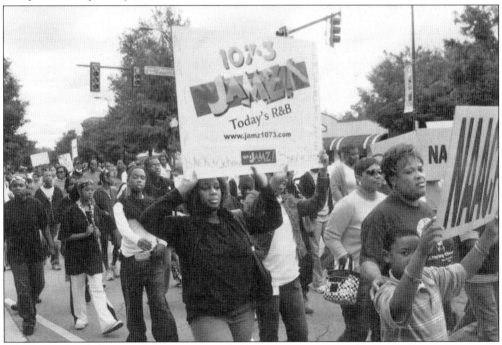

The NAACP Youth Council marches down South Main Street in Greenville to the Greenville Drive Baseball Stadium for a "back to school, stay in school" rally on October 7, 2006, to stem the rising tide of incarceration among black youth as a result of school dropouts. (Courtesy of WJMZ 107.3 JAMZ.)

BIBLIOGRAPHY

BOOKS

City Directory and Gazetter of Greenville, South Carolina, and County. Atlanta: H. H. Dickson Publisher and Printer, 1883.

Crittenden, S. C. *The Greenville Century Book*. Greenville, SC: Greenville News Press, 1963.

DeForest, John W. *Union Officer in the Reconstruction*. Edited by James Crousbore and David Morris Potter. New Haven: Yale University Press, 1948.

DuBois, W. E. B. *Black Reconstruction, 1860–1880*. New York: Harcourt, Brace and Company.

Franklin, John Hope. *Reconstruction after the Civil War*. Chicago: University of Chicago Press, 1961.

Giddings, Paula. *When and Where I Enter*. New York: William Morrow and Company, 1984.

Greenville, South Carolina, City Code, 1912. Compiled by B. A. Morgan, City Clerk, Greenville. Greenville, SC: Greenville News Company Press, 1912.

Katz, William Loren. *Eyewitness: the African American in American History*. New York: Pitman Publishing, 1967.

NEWSPAPERS AND MAGAZINES

The Community Informer.

Dishman, Lydia. "All Business from the Beginning." *Greenville Magazine*, July 2005, 60.

Hughes, E. L. "Prof. Hughes Writes of Schools 30 Years Ago: African American Named Trustee as Rebuke to Political Faith of White Leaders Then." *Greenville Piedmont* (Greenville, SC), August 29, 1930.

"School Chaos." *U.S. News and World Report*, December 7, 1970.

PAPERS AND BOOKLETS

175 Anniversary Committee. *A Look Back: City of Greenville Historical Timeline*. Greenville, SC: City of Greenville, 2006.

Ferguson, Felice. "The Civil Rights Era in Greenville, South Carolina from 1960–1970." Furman University, for Dr. Stephen O'Neill. July 14, 2000.

Greenville County Bicentennial Committee. *We Are a Part of the Bicentennial Celebration of Greenville County, 1786–1986*. Greenville, SC: Greenville Urban League, 1986.

Mathis, Joseph D. *Race Relations in Greenville South Carolina, from 1865 through 1900, as Seen in a Critical Analysis of the Greenville City Council Proceedings and other Related Works*. Thesis submitted to the faculty for the Master of Arts degree, Division of Social Sciences, Atlanta University, August 1971.

O'Neill, Stephen. *Facing Facts: The "Voluntary" Desegregation of Greenville, SC*. Citadel Conference on Civil Rights, March 5–8, 2003.

The Willie Lynch Letter and the Making of a Slave. Chicago: Lushena Books, 1999.

PHOTOGRAPHIC COLLECTIONS AND IMAGES

C. L. Baley Collection. Schomburg Center for Research in Black Culture, New York Public Library.

Robert Bradford Collection.

William B. Coxe Collection. Greenville Historical Society.

David Ezell Henry Jr.

Oscar Landing Collection. Greenville Historical Society.

Owen Riley Collection. *Greenville News*.

James Wilson Collection. Upcountry History Museum.

WJMZ 107.3 JAMZ Collection.

PUBLIC DOCUMENTS

U.S. Bureau of the Census. Population, Volume 9. *Ninth Census of the United States*, 1870.

———. Population, Volume 13. *Tenth Census of the United States*, 1880.

UNPUBLISHED DOCUMENTS

Greenville City Council Proceedings, 1865–1900. Greenville City Hall.

Greenville County Commissioners Proceedings, 1873–1883. Greenville County Courthouse.

Greenville First Baptist Church Proceedings.

Greenville Methodist Church Proceedings.

Greenville County Titles to Real Estate. Office of the Register of Mesne and Conveyance. Greenville County Courthouse.

VIDEO

Smith, Dr. William H. *Sterling High School, a Bootstrap for Generations*. Marlborough, MA: Com Tel Productions, Inc., 1996.

ACROSS AMERICA, PEOPLE ARE DISCOVERING
SOMETHING WONDERFUL. *THEIR HERITAGE.*

Arcadia Publishing is the leading local history publisher in the United States. With more than 3,000 titles in print and hundreds of new titles released every year, Arcadia has extensive specialized experience chronicling the history of communities and celebrating America's hidden stories, bringing to life the people, places, and events from the past. To discover the history of other communities across the nation, please visit:

www.arcadiapublishing.com

Customized search tools allow you to find regional history books about the town where you grew up, the cities where your friends and family live, the town where your parents met, or even that retirement spot you've been dreaming about.